The Digital Photography Book

The step-by-step secrets for how to make your photos look like the pros'! Book

PART 4

Scott Kelby

The Digital Photography Book, part 4

The Digital Photography Book, part 4 Team

TECHNICAL EDITORS
Kim Doty
Cindy Snyder

EDITORIAL CONSULTANT
Brad Moore

ASSOCIATE ART DIRECTOR
Jessica Maldonado

CREATIVE DIRECTOR
Felix Nelson

TRAFFIC DIRECTOR
Kim Gabriel

PRODUCTION MANAGER
Dave Damstra

PHOTOGRAPHY BY
Scott Kelby

STUDIO AND
PRODUCTION SHOTS
Brad Moore
Rafael "RC" Concepcion

PUBLISHED BY
Peachpit Press

Copyright ©2012 by Scott Kelby

Composed in Myriad Pro (Adobe Systems Incorporated) and LCD (Esselte Letraset, Ltd.) by Kelby Media Group.

Trademarks
All terms mentioned in this book that are known to be trademarks or service marks have been appropriately capitalized. Peachpit Press cannot attest to the accuracy of this information. Use of a term in the book should not be regarded as affecting the validity of any trademark or service mark.

Photoshop, Elements, and Lightroom are registered trademarks of Adobe Systems Incorporated. Nikon is a registered trademark of Nikon Corporation. Canon is a registered trademark of Canon Inc.

Warning and Disclaimer
This book is designed to provide information about digital photography. Every effort has been made to make this book as complete and as accurate as possible, but no warranty of fitness is implied.

The information is provided on an as-is basis. The author and Peachpit Press shall have neither the liability nor responsibility to any person or entity with respect to any loss or damages arising from the information contained in this book or from the use of the discs or programs that may accompany it.

THIS PRODUCT IS NOT ENDORSED OR SPONSORED BY ADOBE SYSTEMS INCORPORATED, PUBLISHER OF ADOBE PHOTOSHOP, PHOTOSHOP ELEMENTS, AND PHOTOSHOP LIGHTROOM.

ISBN 13: 978-0-321-77302-9
ISBN 10: 0-321-77302-0

9 8 7 6 5 4 3 2 1

Printed and bound in the United States of America

www.kelbytraining.com
www.peachpit.com

This book is dedicated to the most
amazing woman I have ever known:
my wife, Kalebra.

Acknowledgments

Although only one name appears on the spine of this book, it takes a team of dedicated and talented people to pull a project like this together. I'm not only delighted to be working with them, but I also get the honor and privilege of thanking them here.

To my remarkable wife Kalebra: This year we'll be celebrating our 23rd wedding anniversary, and you still continue to amaze me and everyone around you. I've never met anyone more compassionate, more loving, more hilarious, and more genuinely beautiful, and I'm so blessed to be going through life with you, and to have you as the mother of my children, my business partner, my private pilot, Chinese translator, gourmet cook, rock singer, and very best friend. You truly are the type of woman love songs are written for, and as anyone who knows me will quickly tell you, I am, without a doubt, the luckiest man alive to have you for my wife.

To my wonderful, crazy, fun-filled, son Jordan: If there's anything that makes a dad truly happy deep inside, it's seeing how truly happy deep inside his son is, and Jordan, if you were any happier you'd explode like a candy-filled piñata. As you've now entered your first year of high school, I can't imagine a kid being more on top of the world than you are, and I'm just so proud of the wonderful young man you have become, of the wonderful example you've created for your friends, of the compassion you display for complete strangers, and of your drive to help those in need. One day, when you have kids of your own, you'll understand exactly how I feel about you and why I feel so lucky to be your dad.

To my beautiful "big girl" Kira: You are a "mini-me" of your mom, and that is the biggest compliment I could possibly pay you. You're totally blessed with her outer beauty, and also something that's even more important: her inner beauty, warmth, compassion, smarts, and charm, which will translate into a loving, fun- and adventure-filled, thrilling, drive-it-like-you-stole-it kind of life so many people dream of. You were born with a smile on your lips, a song in your heart, the gift of dance, and a dad who absolutely adores you from the top of your tiara-wearing head to the bottom of your pink sparkly princess shoes.

To my big brother Jeff: A lot of younger brothers look up to their older brothers because, well…they're older. But I look up to you because you've been much more than a brother to me. It's like you've been my "other dad" in the way you always looked out for me, gave me wise and thoughtful council, and always put me first—just like Dad put us first. Your boundless generosity, kindness, positive attitude, and humility have been an inspiration to me my entire life, and I'm just so honored to be your brother and lifelong friend.

To my best buddy Dave Moser: Being able to work with somebody day in and day out, knowing that they are always looking out for you, always have your back, and are always trying to make sure you have everything you need to do your job at work and at home is a real blessing, and I feel like I have a real blessing in you, Dave. Thank you for everything you do for our company, for my family, and for me.

To my editor Kim Doty: Writing books is never easy, but you make my job so much easier by keeping me on track and organized, and by staying absolutely calm and positive in the face of every storm. One of the luckiest things that has ever happened to my books is that you came along to edit them, and I'm very honored and grateful to have you making my books so much better than what I turned in. You are this author's secret weapon.

To my photography assistant and digital tech Brad Moore: I don't know how I would have gotten through this book without your help, your work in the studio (shooting so many of the product shots), your advice and input, and your patience. I'm so grateful to have someone of your talent and character on our team.

To **Jessica Maldonado:** You are, hands-down, the Diva of Design, and I owe much of the success of my books to the wonderful look and feel you give them. What you do brings my books to life, and helps them reach a wider audience than they ever would have, and I'm so thrilled that you're the person that works these miracles for us (signed, your biggest fan!).

To **Cindy Snyder:** A big, big thanks for tech and copyediting all the tips in the book and, as always, for catching lots of little things that others would have missed.

To **Dave Damstra:** You give my books such a spot-on, clean, to-the-point look, and although I don't know how you do it, I sure am glad that you do!

To **my friend and longtime Creative Director Felix Nelson:** We love you. We all do. We always have. We always will. You're Felix. There's only one.

To **my Executive Assistant and general Wonder Woman Kathy Siler:** You are one of the most important people in the building, not only for all the wonderful things you do for me, but for all the things you do for our entire business. Thanks for always looking out for me, for keeping me focused, and for making sure I have the time I need to write books, do seminars, and still have time with my family. You don't have an easy job, but you make it look easy.

To **Kim Gabriel:** You continue to be the unsung hero behind the scenes, and I'm sure I don't say this enough, but thank you so much for everything you do to make this all come together.

To **my in-house team at Kelby Media Group:** I am incredibly blessed to go to work each day with a group of uniquely dedicated, self-motivated, and incredibly creative people—people who mean much more to me than just employees, and everything they do says they feel the same way. My humble thanks to you all for allowing me to work with the very best every day.

To **my dear friend and business partner Jean A. Kendra:** Thanks for putting up with me all these years and for your support for all my crazy ideas. It really means a lot.

To **my editor at Peachpit Press, Ted Waitt:** Do you know what a joy it is to work on a photo book with an editor who's also a passionate and creative photographer? It makes a huge difference. Be the love. Share the love. Make the love (whoops, scratch that last one).

To **my publisher Nancy Aldrich-Ruenzel, Scott Cowlin, Sara Jane Todd, and the incredibly dedicated team at Peachpit Press:** It's a real honor to get to work with people who really just want to make great books.

To **all the talented and gifted photographers who've taught me so much over the years:** Moose Peterson, Vincent Versace, Bill Fortney, David Ziser, Jim DiVitale, Helene Glassman, Joe McNally, Anne Cahill, George Lepp, Cliff Mautner, Kevin Ames, David Tejada, Frank Doorhof, Eddie Tapp, Jack Reznicki, and Jay Maisel, my sincere and heartfelt thanks for sharing your passion, ideas, and techniques with me and my students.

To **my mentors John Graden, Jack Lee, Dave Gales, Judy Farmer, and Douglas Poole:** Your wisdom and whip-cracking have helped me immeasurably throughout my life, and I will always be in your debt, and grateful for your friendship and guidance.

Most importantly, I want to thank God, and His Son Jesus Christ, for leading me to the woman of my dreams, for blessing us with such amazing children, for allowing me to make a living doing something I truly love, for always being there when I need Him, for blessing me with a wonderful, fulfilling, and happy life, and such a warm, loving family to share it with.

Other Books By Scott Kelby

The Digital Photography Book, vols. 1, 2 & 3

Professional Portrait Retouching Techniques for Photographers Using Photoshop

Light It, Shoot It, Retouch It: Learn Step by Step How to Go from Empty Studio to Finished Image

The Adobe Photoshop Lightroom Book for Digital Photographers

The Adobe Photoshop Book for Digital Photographers

The Photoshop Elements Book for Digital Photographers

Photoshop Down & Dirty Tricks

The iPhone Book

About the Author

Scott Kelby

Scott is Editor, Publisher, and co-founder of *Photoshop User* magazine, is Publisher of *Light it!* digital magazine, and is co-host of the weekly videocasts *The Grid* (the weekly photography talk show) and *Photoshop User TV*.

He is President of the National Association of Photoshop Professionals (NAPP), the trade association for Adobe® Photoshop® users, and he's President of the software training, education, and publishing firm Kelby Media Group.

Scott is a photographer, designer, and award-winning author of more than 50 books, including *The Digital Photography Book*, volumes 1, 2, and 3, *The Adobe Photoshop Book for Digital Photographers*, *Professional Portrait Retouching Techniques for Photographers Using Photoshop*, *The Adobe Photoshop Lightroom Book for Digital Photographers*, *Light It, Shoot It, Retouch It: Learn Step by Step How to Go from Empty Studio to Finished Image*, and *The iPhone Book*.

For the past two years, Scott has been honored with the distinction of being the world's #1 best-selling author of books on photography. His books have been translated into dozens of different languages, including Chinese, Russian, Spanish, Korean, Polish, Taiwanese, French, German, Italian, Japanese, Dutch, Swedish, Turkish, and Portuguese, among others.

Scott is Training Director for the Adobe Photoshop Seminar Tour, and Conference Technical Chair for the Photoshop World Conference & Expo. He's featured in a series of training DVDs and online courses, and has been training photographers and Adobe Photoshop users since 1993.

For more information on Scott, visit him at:

His daily blog: www.scottkelby.com
Twitter: http://twitter.com/@scottkelby
Facebook: www.facebook.com/skelby
Google+: Scottgplus.com

Table of Contents

Table of Contents

Table of Contents

Table of Contents

Table of Contents

Table of Contents

Chapter One

Shooting People Like a Pro

Yet Even More Tips to Make People Look Their Very Best

I think one of the most wonderful things about shooting people is that they're one of the few things that you'll ever shoot that will actually talk to you. Think about it—if you shoot landscapes, or HDR shots, or architecture, or cars, or home interiors, it's very unlikely that any of these will actually carry on a conversation with you, unless (and this is a big unless) you're on LSD. In that case, everything will talk to you. Bunnies. Rainbows. Mountains. Door handles. You name it. Now, you do run a serious risk when taking LSD and that is you may become annoyed at constantly hearing from these inanimate objects, because, like people, they don't always say exactly what you want them to say. For example, I remember this one time during the 1960s, when I was listening to this Jimi Hendrix song while crossing a rice paddy with my platoon (looking back, it may not have actually been a rice paddy, it may have been a small drainage ditch at the golf course behind my parents' house, and since I was probably about five years old, I guess I wasn't with my platoon, it was more likely the two neighbor kids that lived next door, and I imagine I wasn't listening to Jimi Hendrix, it was more likely "This is the way we wash our hands, wash our hands, wash our hands…" from the *Captain Kangaroo* show I watched that morning before heading off to kindergarten, but the '60s were such a blur for me). Anyway, when you shoot people, there are a few things you want to make sure of: (1) Hide the gun. This is the first thing the cops are going to go searching for. (2) Wipe everything clean of fingerprints. (3) When you hear, "It's the police. Open up!" don't freak out and accidentally flush your 70–200mm f/2.8 lens down the toilet. You cannot believe how long it takes for one of those to dry out.

9 Things You'll Wish You Had Known…

(1) You don't have to read this part, because I created a video that explains how to get the most out of this book. It's short and to the point, but I promise it'll make using and learning from this book much more enjoyable (plus, you can skip this section, because the video covers it). You can find it at **http://kelbytraining.com/books/digphotogv4**.

(2) Here's how this book works: Basically, it's you and me together at a shoot, and I'm giving you the same tips, the same advice, and sharing the same techniques I've learned over the years from some of the top working pros. But when I'm with a friend, I skip all the technical stuff. So, for example, if you turned to me and said, "Hey Scott, I want the light to look really soft and flattering. How far back should I put this softbox?" I wouldn't give you a lecture about lighting ratios or flash modifiers. In real life, I'd just turn to you and say, "Move it in as close as you can to your subject, without it actually showing up in the shot. The closer you get, the softer and more wrapping the light gets." I'd tell you short and right to the point. Like that. So that's what I do here.

(3) This picks up right where volume 3 left off (the previous books in this series should have been called parts 1, 2, and 3, instead of volumes 1, 2, and 3, so that's why I called this one part 4), and the stuff here is what people who bought volume 3 told me they wanted to learn next. So, for example, in the chapter on hot shoe flash, I don't tell you what your flash's groups are for, because all that was already covered in the flash chapter in volume 3. Instead, it picks up right after that, with all new stuff. Now, should you have volumes 1, 2, and 3 before…

...Before Reading This Book!

...you read this book? It's not absolutely necessary, but it certainly wouldn't bother me one bit if you did (like how I phrased that? A very subtle, soft-sell approach. Compelling, but yet not overbearing). All joking aside, if you're into off-camera flash or studio lighting, it is helpful to have read at least volumes 2 and 3, because I treat those chapters in this book as if you already learned the basics in volumes 2 and 3.

(4) Sometimes you have to buy stuff. This is *not* a book to sell you stuff, but before you move forward, understand that to get pro results, sometimes you have to use some accessories that the pros use. I don't get a kickback or promo fee from any companies whose products I recommend. I'm just giving you the exact same advice I'd give a friend.

(5) Where do you find all the gear I mention? Since I didn't want to fill the book with a bunch of web links (especially since webpages can change without notice), I put together a special page for you with a link to any of the gear I mention here in the book. You can find this gear page at **http://kelbytraining.com/books/vol4gear**.

(6) The intro page at the beginning of each chapter is just designed to give you a quick mental break, and honestly, they have little to do with the chapter. In fact, they have little to do with anything, but writing these off-the-wall chapter intros is kind of a tradition of mine (I do this in all my books), so if you're one of those really "serious" types, please, I'm begging you—skip them, because they'll just get on your nerves.

That Was Only 6. Here Are the Last 3

(7) If you're shooting with a Sony or Olympus or a Sigma digital camera, don't let it throw you that a Nikon or Canon camera is pictured. Since most people are shooting with a Nikon or Canon, I usually show one or the other, but don't sweat it if you're not—most of the techniques in this book apply to any digital SLR camera, and many of the point-and-shoot digital cameras, as well.

(8) There are extra tips at the bottom of a lot of pages—sometimes they relate to the technique on that particular page, and sometimes I just had a tip and needed to fit it somewhere, so I put it on that page. So, you should probably at least take a quick glance anytime you see a tip box on the bottom of a page—ya know, just in case.

(9) Keep this in mind: This is a "show me how to do it" book. I'm telling you these tips just like I'd tell a shooting buddy, and that means oftentimes it's just which button to push, which setting to change, where to put the light, and not a whole lot of reasons why. I figure that once you start getting amazing results from your camera, you'll go out and buy one of those "tell me all about it" digital camera or lighting books. I do truly hope this book ignites your passion for photography by helping you get the kind of results you always hoped you'd get from your digital photography. Now, pack up your gear, it's time to head out for our first shoot.

Getting Shallow Depth of Field with Studio Strobes

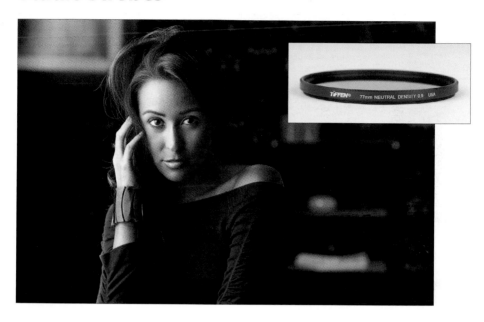

Generally, in the studio, everything's in focus (our subject, the background, you name it), because even at your strobe's lowest power setting, you still probably have to shoot at around f/8 to f/11, and that's great for most of the portraits you'll be shooting. But, what if you've built a set in the background, or you're using a scenic backdrop, or textured background, and you want it to be blurry and out-of-focus? You can't switch your f-stop to f/2.8 or f/4, because your shot would be way overexposed. So, what's the trick to getting soft, blurry backgrounds in the studio? It's using a filter that we would normally use outdoors to shoot waterfalls and streams—a neutral density filter (called an "ND filter"). This filter is totally see-through, but really dark, and basically it makes what your lens sees much darker. So dark that, to get a proper exposure, you actually have to lower the f-stop to around f/4 or f/2.8 (pretty tricky, eh?). You'll want to use either a 3- or 4-stop filter (these are made by B+W, Hoya, and Tiffen [shown above], among others) and they screw right onto the end of your lens (make sure you order one that fits your particular lens). That's it— pop the ND filter on your lens, and you're set to shoot at wide-open f-stops like f/2.8 or f/4.

Shooting Multiple Exposures In-Camera

Back in the film days, to shoot a multiple-exposure shot (one frame with two or more images in it), we used to have to take a shot, carefully rewind the film, and take another shot, and sometimes it actually worked! (Of course, back when I used to shoot film, I also couldn't make a call in my car, because cell phones hadn't been invented yet.) Anyway, while you can easily put two images together in Photoshop, you can actually do it in-camera pretty easily, too (a great example of this is Joe McNally's multiple-exposure shot of comedian Steve Martin). On Nikon DSLRs, go to the Shooting menu and choose Multiple Exposures. Press the right arrow on the multi-selector (on the back of your camera), choose Number of Shots, and press the right arrow again. Now, choose how many exposures you want (start with 2 the first time you try this) and press the OK button (also on the back of your camera). Next, make sure Auto Gain is turned On, then click the OK button (turn Auto Gain Off if the background you're shooting on is black). Now, take a shot, then have your subject move (or aim at something else), and shoot a second shot, and both images will appear in the same frame. Most Canon cameras don't have this function built-in, so you'll need to take two shots and blend them into one frame in Photoshop (or Photoshop Elements), so open both images in Photoshop. Step One: With the Move tool (V), press-and-hold the Shift key, and drag one image on top of the other. Step Two: Click on the Add Layer Mask icon at the bottom of the Layers panel. Get the Gradient tool (G), press the letter X on your keyboard to set your Foreground and Background colors to black/white, and then click-and-drag the Gradient tool through the top image, and it blends the two images together (it's easier than it sounds—give it a try).

One Person, Multiple Times, in the Same Shot

The trick to getting this look is amazingly simple in the studio, but you'll need to use Photoshop or Photoshop Elements to do the final step (it's really easy to pull off, even if you're fairly new to Photoshop). You start by putting your camera on a tripod (this is key, because the camera can't move, even a little, during your shoot. Well, it could, but it makes your job in Photoshop a whole lot harder). Anyway, once your camera is on a tripod, take your first shot. Now, have your subject take a few steps to the left or right of where they were just standing and take another shot. Repeat this two or three more times (you can have them dance around, jump around, etc., they just have to do it in a different place each time). Next, open the first photo you took in Photoshop (or Photoshop Elements), and then open the second photo. Step One: Get the Move tool (V), press-and-hold the Shift key, then drag the second photo on top of your first one (holding the Shift key perfectly aligns the two images together). Step Two: Click on the Add Layer Mask icon at the bottom of the Layers panel, then get the Brush tool (B), choose a small, soft-edged brush from the Brush Picker in the Options Bar, set your Foreground color to black, and paint away any edges or background that overlaps. Open another image and do the same thing (Shift-drag, add a layer mask, and paint away anything you don't want). If this sounds hard or funky or anything other than, "Oh man, is that all there is to it!?" then don't worry—I made a short video (you can find it on the book's companion website) that shows how I put the image you see above together. Then, you'll go, "Oh man, is that all there is to it!?"

How to Freeze Motion in Portraits

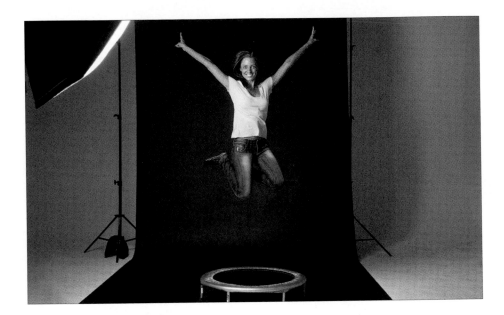

For the most part, if you're taking a portrait using a studio strobe, the flash of the strobe will freeze any movement (like hair blowing with a fan). But, if you're going to have your subject running through the image (like an action portrait of a runner or other athlete, or a ballerina spinning, or a contemporary dancer jumping on a trampoline), you're going to need a faster flash duration. In that case, the easiest thing to do is to turn off your studio strobes and switch to a hot shoe flash (like a Nikon SB-910 or a Canon 580EX II). These have a faster flash duration (that's one reason they're called "speedlights") and that short flash duration will freeze your subject in mid-air no problem, and the image will be sharp as a tack (also, the lower the power setting of a hot shoe flash, the shorter the flash duration). You can do this with studio strobes, as well, but there are a few things you'll need to do for this to work: (1) You'll need to shoot on a black background (it has to be really dark, so we're not doing this outside during the day, for the most part). (2) You need to set your shutter speed to its highest sync speed (generally 1/200 for studio lights, or 1/250 for hot shoe flash), because you want your flash to be the only light hitting your subject, and because of that, you want the existing light in the room (called "ambient light") to be as dark as possible (in fact, ideally, you don't want any room light at all, and that high shutter speed will help with that big time). And, (3) for most strobe brands, you want to keep your studio strobe's power setting as low as possible (the lower the power, the shorter the flash duration, and that shouldn't be a problem in a pitch black room— you'll only need a little flash power to fully light your subject).

Avoid Seeing Too Much "Whites of the Eyes"

Bad

Good

One thing that ruins a lot of portraits where the subject isn't looking straight at the camera is when you see too much of the whites of the eyes. Luckily, once you're aware of the problem, there's a pretty easy fix: have them look just to the left (or right) of your camera position. I usually hold my hand all the way out to the side and tell my subject to look right where my hand is. If they stay looking right there, you'll see plenty of their iris and you won't have that creepy looking "white eye" effect.

More Tips for Great Group Shots

What's one of the biggest challenges with group shots (besides lighting them evenly, which is actually easy—just move the light way back)? It's seeing everyone's face. Invariably, someone's head is hiding behind someone else's (or their hair, or a hat, etc.). The trick? Take a stepladder and shoot from a higher perspective. That way, everybody's looking up, and there's less chance for anybody to be hidden. Another tip: Time is your enemy, because the longer this takes, the more disinterested the group becomes in the portrait. So, once you get everybody in place, take the darn photo (snap off seven or eight shots really quickly and be done). Lastly, before you assemble everybody, ask one or two people from the group to help out, and then direct them to move this person or that person. That way, you only need to know two people's names.

How to Keep a Group Portrait Shoot from Going Off the Rails

Remember that you're the director of this group portrait, and if you're buried behind the camera with your eye stuck to the viewfinder, you're going to lose the crowd. They'll start talking amongst themselves, and getting them to focus back on you is going to be tough. If you can, shoot your group shot on a tripod and use a cable release, so you're standing right in front of them, directing the whole time. Also, if you're talking to them, they won't have time to start chatting with each other, and you'll keep the train moving forward and on track. Don't mess around—make it quick!

Better Than the Self Timer for Group Shots

This technique for taking group shots where you need to actually be in the shot is much better than just using the self timer on your camera, because the self timer only takes one shot (and one group shot is never enough. In fact, two or three generally aren't enough, especially with a big group). Nope, instead, you're going to use an interval timer (also called an intervalometer), which makes your camera automatically take a series of shots at whatever time interval you choose (I generally go with one shot every three seconds). So, you start the interval timer, go get in place within the group, and the camera will start firing off shots for you. Some Nikon DSLRs have this feature built in (from the Nikon D200 on up), and in that case, you go under the Shooting menu and choose Interval Timer Shooting. In the menu that appears, you can choose when the shooting starts, how often it takes a shot, and so on. If you have a Canon DSLR, or a Nikon that doesn't have this interval timer feature built in, then you can buy an accessory that plugs right into your camera's remote shutter release port that will do it for you (like the Vello Wireless ShutterBoss Timer Remote shown above. I've seen some digital remote timers for as low as around $12 online).

Focus on the Subject's Eye, Then Recompose

If you want to absolutely nail the focus when you're shooting portraits, then your subject's eye needs to be in super-sharp focus. If the eye isn't in focus, the rest doesn't matter, so it's got to be right on the money. By the way, when I say "eye," I mean the eye closest to the camera (of course, if they're standing there with their shoulders and head facing directly toward the camera, both of their eyes should be the same distance from the camera. If not, they have an entirely different problem that's not going to be fixed with a camera). Anyway, here's the technique I use: (1) Aim the focus point on your LCD (usually a red dot or a red rectangle) directly at the eye closest to the camera (again, if their shoulders are square, straight toward the camera, just pick an eye), then (2) press the shutter button halfway down to "lock the focus" on their eye. Lastly, (3) with that shutter button still held halfway down, recompose the shot any way you'd like. Now, when you actually press the shutter button all the way to take the shot, your focus will be right on the money.

That Works Unless You're Shooting at f/1.4

The "lock focus and recompose" tip I just shared on the previous page works for almost every situation, with almost one exception: when you're shooting a portrait with your f-stop set to f/1.4, or maybe even f/1.8 (of course, you have to have a lens capable of shooting at that wide an f-stop, so if you don't have one of those, you can skip this tip altogether). The problem comes from the fact that when you're shooting at f/1.4 (for example) and you focus on the eye, then lock the focus and recompose the shot, the depth of field is so incredibly shallow that the recomposing part can actually put the eye a little bit out of focus (crazy, I know, but this is why you sometimes read in online forums people claiming that their $1,800 lens doesn't take crisp photos). So, when shooting at a super-wide-open f-stop like this (f/1.4, or even f/1.8), what you need to do is compose the shot the way you want it first, then manually move the focus point over the person's eye using the multi-selector (or multi-controller) on the back of your camera. That way, once it's aiming at their eye, it doesn't move. Now take the shot, and the sharpness of the eye will be right on the money. A big thanks to Cliff Mautner for this tip.

Creating the Blown-Out Look

I talk about doing this in the studio chapter, but if you don't have studio lighting, you're probably not going to read that chapter, so I wanted to include a version of it here for portraits. The "blown out" look (where you have really bright light behind your subject, so the photo almost looks blown out, or it has a big burst of light from the sun in it, or both) is really hot right now (this kind of cracks me up, because for years we've gone out of our way to avoid blowing out our photos, and now here I am writing a tip on how to actually blow them out). There are basically three tricks here, all of them simple: (1) Remove your lens hood (I know, that seems kind of obvious, but not everybody realizes the main job of a lens hood is to reduce lens flare, but now-a-days lens flare is cool, so if it flares, it's a win. Go figure). Then, (2) position your subject so the sun is behind them and you're kind of "shooting into the sun," and then (3) overexpose your shot a little bit by overriding what your camera says is a proper exposure. You do this using your camera's exposure compensation features (see page 80) by anywhere from 1 to 2 stops, depending on how "blown out" you like your images. However, exposure compensation doesn't work if you're shooting in manual mode (in which case, you have to overexpose manually, either by using a lower-numbered f-stop, or using a slower shutter speed, or both. Remember, when it looks really bad and really blown out…that's good!). One last thing: if you have your camera's Highlight Warning turned on, it should be blinkin' like a strobe at a disco—blown out look means blown out highlights (going to solid white in some or a lot of areas).

A Better Way to Direct Your Subject's Posing

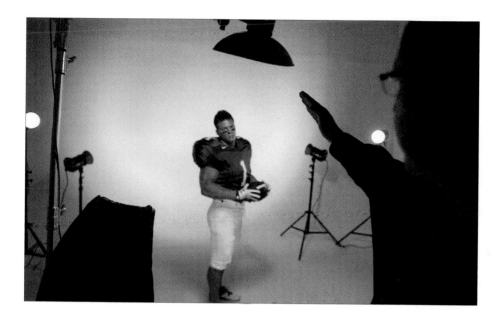

I've spent so many years shooting portraits and telling my subjects things like, "Move to your left a bit. No, my left. The other left. Uggh!" This stinks because your subject feels dumb for moving the wrong direction, you get frustrated because you just moved them the wrong direction, and the whole thing just doesn't have to happen if you use this great trick I learned from my buddy Jack Reznicki: stop giving them left/right directions. That's right, instead, just hold your hand up in front of you (as shown above) and then move your hand in the direction you want them to go, and by golly, they'll follow right along like a trained seal (so to speak). You can use this hand technique to move them forward, backward, to tilt their head one way or the other (no more "Tilt your head to the left. No, my left"), and so on.

Remembering Your Subject's Name

While we're talking about tips from Jack, here's another one I learned from him and I've been using it ever since, because I'm terrible at remembering people's names (although I never forget a face). At the beginning of the session, take a piece of white gaffer's tape and write your subject's name on it, and put that piece of tape right on the back of your camera. That way, it's always right there in front of you, and you can always refer to your subject by name (and you should. "Hey you" just falls kinda flat).

Only Photographers Care About the Characteristics of Catch Lights

Catch lights are those white reflections of the light source that appear in your subject's eyes (reflecting either the sun, or the softbox, or the reflector you used when you made the shot) and they're important, because they add life and sparkle to the eyes—without them the eyes kind of look dead. However, the fact that you do have catch lights in the eyes is really all you need to worry about, because the only people in the world that ever notice or care about the shape, size, or position of catch lights are other photographers. That's it. The public pays no attention whatsoever, so don't waste even two minutes worrying about how many catch lights you see in your subject's eye, or the shape of them, or if your reflectors can be seen in them. The only people that might ever care will never be hiring you to do a shot, since they're photographers already. So, thankfully, we can take the size, shape, position, and frequency of catch lights off our worry list.

Don't Worry About Your Softbox Reflecting in Sunglasses Either

Here's another thing not to sweat: softbox reflections in sunglasses. If you've been sweating this one, one trip to the local sunglass store in the mall should allay your concerns, as you'll see photo after photo with the softbox clearly reflected (you can walk around and see exactly what the photographer took each shot with—"Let's see…that one's a beauty dish. That's an umbrella. That one's an Octabank…").

What Not to Shoot with Your 50mm Lens

50mm

200mm

Don't shoot portraits of women. Well, certainly not close-up portraits anyway, and for one simple reason—it's just not flattering. When you shoot people with a 50mm lens up close, they generally look a bit distorted and that's the last thing you want in a portrait. That's why you see the pros shooting with longer lenses so often (I usually shoot with a 70–200mm lens out around the 150mm to 200mm end of the lens most of the time). These longer lengths create a compression that's very flattering in portraits, so people just plain look better (and why wouldn't you want your subjects to look better?). Now, can you shoot a full-length bridal portrait from the back of the room with a 50mm lens? Sure. Can you shoot group shots with a 50mm? Absolutely. Should you shoot a close-up head shot? Only if you don't care about working for that client again, because they're not going to be happy with the results. The 50mm is great for some instances, but when it comes to shooting portraits of women, almost any longer lens would probably be a better choice. By the way, I didn't need to mention the whole "don't shoot portraits of women with a fisheye lens," did I? (Kidding. I hope.)

Posing Tip to Make Her Eyes Look Bigger

Here's a quickie for larger, more flattering eyes: have your subject keep her chin down just a little bit. This puts a little extra "white" under the irises, and makes her eyes look bigger and better.

Getting Both What's in Front & Back in Focus

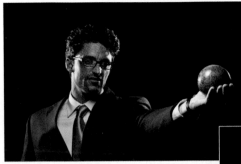

Subject in Focus

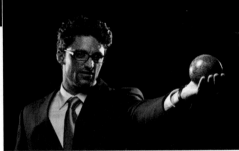

Object in Focus

If you're shooting a subject who's holding something out in front of them, like a football, flowers, etc., even at f/11 (where usually everything is in focus), something's going to be out of focus—either your subject or the object they're holding (and, of course, you want everything in focus). Luckily, there's a trick for this: First, it's easier if you shoot on a tripod, but you can absolutely hand-hold. Then, the trick is to take two shots, one right after the other—one where your subject is in focus, and one where the object is in focus—and merge them into one in Photoshop (it's simple). Compose your shot the way you want it and position your focus point (the red dot or rectangle) right over your subject's eye, so they'll be in sharp focus, and take the shot. Then, immediately move your focus point over onto the object your subject's holding and take another shot (the object will be in focus, but your subject will be a bit blurry). Open the first shot in Photoshop, then open the second one (the one where the object is in focus). Step One: Get the Move tool (V), press-and-hold the Shift key, and drag the second shot on top of the first one (holding the Shift key perfectly aligns the two together. However, if you hand-held, you'll need to select both layers in the Layers panel and choose Auto-Align Layers from the Edit menu). Step Two: Press-and-hold the Option (PC: Alt) key and click on the Add Layer Mask icon at the bottom of the Layers panel to hide the object layer behind a black layer mask. Now, get the Brush tool (B), choose a small, soft-edged brush from the Brush Picker in the Options Bar, set your Foreground color to white, and paint over the object. Voilà! It's in focus now, too!

Two Quick Composition Tips

When you're composing your portraits, if you're not shooting full-length, you're probably going to have to make some decisions about which body parts it's okay to cut off in the shot. In other words, if you're not shooting full-length, at some point, you're going to have to cut off your subject's legs, and if so, where is the "right" place to crop them? This is an easy one—crop them above the knee. If you compose it so you're cutting them off below the knee, they get that double-amputee look, so stay above the knee. You can apply that same rule if you're shooting in tighter—where is it okay to chop off their arms? I would do it above the elbows for the same reason. Any lower and it looks like they actually have had something chopped off. Take a look in any fashion magazine, and you'll see that while they do chop off a lot of things, they're usually above the elbow and above the knee.

When Do You Need Model Releases?

If you shoot people and you're not sure when you need to get a model release signed, you should pick up a brilliant book by photography copyright attorney Ed Greenberg and one of the leading advocates of copyright issues for photographers, Jack Reznicki. The book is called *Photographer's Survival Manual: A Legal Guide for Artists in the Digital Age*. It'll save your bacon.

How to Get Better Full-Length Photos

Shot Standing *Shot Sitting*

I have so many photographers tell me they don't know what the problem is, but their full-length photos just don't look "right." That's probably because they're standing there shooting their full-length shots, but to get the right look and perspective, the trick is to shoot these from a really low perspective. I generally shoot from either a lying down position, or sitting down on the ground in a cross-legged position. This makes a huge difference (much bigger than you'd think)—the change in perspective makes your subject's legs look longer, it makes them look taller and thinner (who doesn't want to look taller and thinner?), and it even changes how the lighting looks on the background. So, you get all sorts of benefits from changing your shooting angle when it comes to full-length shots.

Controlling the Size of Your Subject

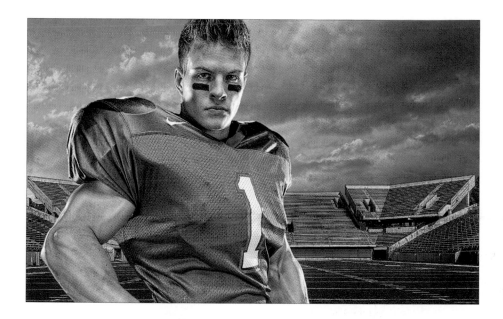

Sometimes, you want something in the foreground of your image to be the large, main focal point. For example, let's say you're shooting a high school football player in the team's stadium, and you want the player to appear huge, and the stadium to be somewhat smaller in the background. Your first inclination might be to zoom in on the player, but that only crops him in the photo—you need to change the perspective and zooming in won't do it. Instead, switch to a wide-angle lens, and then physically move in really tight to the player. That will give him a "larger than life" look, and if you really want to get the most bang for the buck from this look, get down on one knee and shoot up at the player, which exaggerates the effect even more.

SHUTTER SPEED: 1/125 SEC F-STOP: F/6.3 ISO: 200 FOCAL LENGTH: 24mm PHOTOGRAPHER: SCOTT KELBY

Chapter Two

Using Hot Shoe Flash Like a Pro, Part 3

Picking Right Up Where the Last Book Left Off

Did you ever see that movie *William and the Awkward Alterations Fitting* with Ethan Washington and John Trumann? If you didn't see it, I'm not surprised—it kind of flopped at the box office (it probably should have gone straight to DVD). Anyway, there's this pivotal scene in the movie where Sgt. Buck Logan (played sublimely by British actor Theodore Cowlin) hands his saucy one-armed lab assistant Christina (played by Tony-award-nominated actress Sara Jane Todd) a white 1-stop shoot-through umbrella and he tells her to take a tilter bracket and attach it, along with the shoot-through, to the end of a monopod for their location shoot later that day. Sounds pretty simple, but just as she starts to thread the bracket onto the monopod, "Mr. Fluffels," her precocious miniature labradoodle with a long-since diagnosed incontinence problem, suddenly jumps up from her doggie bed, perched up high on the window where Dr. Latisaw (Trumann) likes to watch the hummingbirds feed in the frosty morning air, and literally leaps right into the open shoot-through umbrella (which was lying nearby on the studio floor) and it was as if someone had opened a jar of peanut butter in there (Mr. Fluffels' favorite treat, revealed earlier in the movie). Well, it's just a calamity, and sure enough, her paw goes right through the thin diffusion fabric, and Mr. Fluffels starts running all over the studio with this umbrella attached to her leg, and well…I was laughing so hard I had tears in my eyes. Not only because this was such an over-used theatrical ploy, but because in plain sight, right on the rickety old wooden workbench behind Sgt. Logan, was a Lastolite EzyBox 21" softbox, which would have been the obvious choice, rather than a shoot-through umbrella, and anyway, the whole thing was just a hoot. You could instantly tell who the other hot shoe flash photographers in the theater were, because none of us could contain our laughter. We were all yelling "Use the EzyBox you idiot!" The usher had to come over and warn us twice.

Shooting Your Flash in Manual Mode

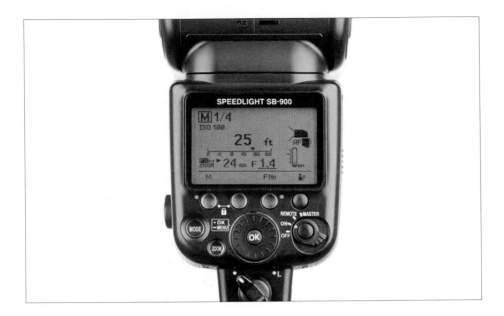

The flash manufacturers won't be thrilled to read this, but I'm not a big fan of TTL flash (Nikon's is called i-TTL and Canon's is called E-TTL, but they basically do the same thing—they use "through-the-lens" [TTL] metering to give you a better flash exposure automatically). When it works, it works really well. The problem is that it doesn't always work, and you don't always know why. That's why, when I work with hot shoe flash, I work in Manual mode on the flash (where I raise and lower the power manually, rather than having the flash make the decisions for me). For a location shoot, I set my flash to Manual mode, then I start with my power setting at ¼ power and do a test shot. If the flash is too dark, I crank it up to ½ power and take another test shot. If it's too bright, I drop it to ⅛ power and take a test shot. It normally takes me just a minute or two to find the right amount of flash to balance with the existing light in the location I'm shooting, so the light looks natural. I see more photographers frustrated with TTL than I do in love with it. Personally, I think, if anything, TTL usually makes the flash too bright and too obvious, so if I'm going to have to override it anyway, I might as well just control the power myself and leave all the frustration and aggravation behind. But hey, that's just me—there are people who love it. The cool thing is, you can try both methods and see which one fits your style (subliminal message: go Manual and you'll never go back).

The Trick to Keep from Lighting the Ground

With Flash

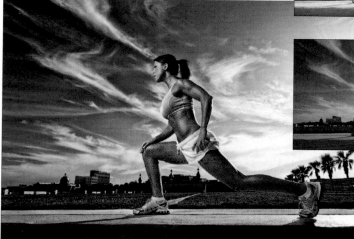

Without Flash

When you're shooting a subject in sunlight, or in low light with flash, you want to light your subject, but you don't generally want to light the ground they're standing on (after all, the ground isn't the subject). It's often a bit cumbersome, though, to try to coax the light to only fall on your subject and then stop right there and not light the ground. That's why this tip, which I learned from David Hobby, rocks (it's ½ camera trick and ½ Photoshop trick). Here's how it works: When you take your shot, take two real quick shots in a row (you can use burst mode, if you like). On the first shot, your flash will fire, but it won't have time to recycle for the second shot, so the second shot is taken with just the available light at the scene. So, you have two shots now: one with the flash lighting your subject (and the ground) and one where the flash didn't fire and the ground looks normal. Open both photos in Photoshop (or Photoshop Elements). Press-and-hold the Shift key, get the Move tool (V), and drag the shot where the flash didn't fire on top of the one where it did, and it'll appear on its own separate layer (holding the Shift key down as you drag perfectly aligns the two images, one on top of the other). Now, press-and-hold the Option (PC: Alt) key and click on the Add Layer Mask icon at the bottom of the Layers panel. This puts a black mask over the top layer (the one where the flash didn't fire), which hides it from view. Get the Brush tool (B), choose a medium-sized, soft-edged brush from the Brush Picker in the Options Bar, set your Foreground color to white, and paint over where the flash lit the ground. As you paint, it reveals the ground from the shot where the flash didn't fire, which covers the spillover from the flash. (*Note:* I created a short video to show you how this works and how to create the finishing effect, which you can find on the book's companion website.)

Using Studio-Quality Softboxes with Your Flash

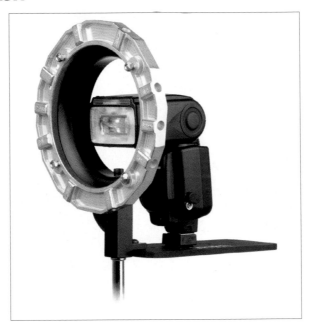

If you want to get real studio-quality lighting out of your off-camera flash, you'll need real studio softboxes, and one of the tricks to using them is an accessory called the Magic Slipper from F.J. Westcott (www.fjwestcott.com). The Magic Slipper lets you use nearly any studio softbox that Westcott makes (and they make a bunch) with your hot shoe flash. So, now you can use big octabanks, and strip lights, and huge rectangular softboxes—pretty much whatever you want from their collection of studio gear. There's also a company called Kacey Enterprises (www.kaceyenterprises.com) that has a speed-light adapter and ring that lets you use an Elinchrom softbox with your speedlights. You need both the Kacey Speedlight Bracket (you mount this on top of your light stand to hold either one or two Canon or Nikon flashes, depending on which model you order), and then you need the Kacey/Eli Adapter, which you attach to your Elinchrom softbox. Both the Westcott and Kacey solutions are about the same price (around $230 when this book was published). It's not cheap, but it opens up a new world of light modifiers (fancy word for softboxes) to you.

Mounting a Flash on a Monopod

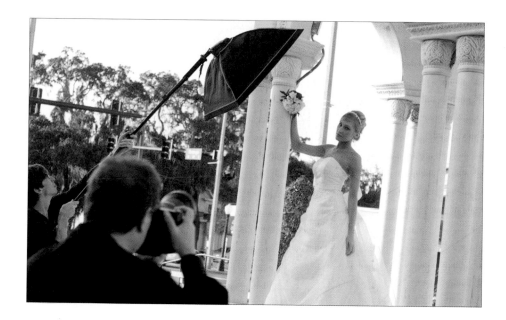

If you have someone that can help you during your shoot (a friend, a paid assistant, etc.), then you can use a rig that is becoming extremely popular, especially for shooting weddings and portraits on location, and that is your hot shoe flash mounted on a monopod (a single telescoping pole usually used to support large lenses for sports photographers). Then, to soften the light, you either add a shoot-through umbrella or, what I prefer, a small pop-up softbox (like Lastolite's EzyBox Hotshoe softbox). This rig really lets you "run and gun," because there's nothing to pick up and move—no stands or sandbags to haul around—and you can shoot in close quarters without having to worry about maneuvering the legs of your light stand (plus, you can shoot outdoors without having to worry about a gust of wind sending your lighting rig sailing!). The key to this rig is an adapter made to fit on the top of the monopod. Believe it or not, though, you might already have one that works with a softbox. That's right—you know that little plastic stand that comes in the box with Nikon and Canon flashes? If you turn it upside down, you'll find an opening for screwing this into a monopod. Just screw the stand into the top of the monopod, then put your flash on the stand. If you want something sturdier, that works with an umbrella, B&H Photo sells Impact's Umbrella Bracket with Adjustable Shoe, which also tilts, so it's perfect for using with a shoot-through umbrella. If you're using a hot shoe EzyBox, it already comes with an adapter that screws onto a monopod. Once your flash is on the monopod, and you have a wireless trigger attached to your flash, you or your helper can now move very quickly from location to location with no wires, stands, or other mess to slow you down.

How to Put the Background Out of Focus Using Flash

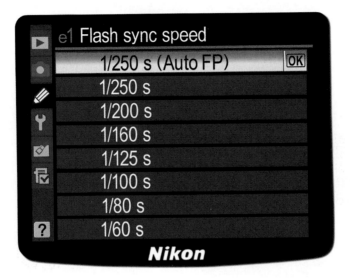

You'll notice that most images taken with flash have the background, along with pretty much everything else, in focus because, for a proper exposure, they're probably taken at f/8 or f/11. That's mostly because, with hot shoe flash, your shutter speed needs to stay at a maximum of ½50 of a second or your camera and your flash won't stay in sync (called the maximum sync speed). If it goes above ½50 of a second, you'll see a dark gray or black gradient appear across the top or bottom of your image (and the more you're over ½50 of a second, the bigger that gradient will be). So, to shoot at wide-open apertures like f/4 or f/2.8 (f-stops that put the background out of focus), you'd need to have your shutter speed way above ½50 of a second, especially if you're shooting in daylight. To be able to use the high shutter speeds, so you can shoot at those wide-open apertures like f/2.8, turn on High-Speed Sync. (Really, that's it? Well...yeah.) On a Nikon, go under the Custom Setting menu, under Bracketing/Flash, and choose Flash Sync Speed. From the list of sync speeds, choose ½50 s (Auto FP)—the FP stands for Focal Plane. Now, if you look on the back of your flash, you'll see "FP" appear at the top of the LCD. You can now sync up to ⅛000 of a second, so with your camera in manual mode, you can dial in pretty much whatever shutter speed you need to get the wide-open f-stop you want. For a Canon, you turn this feature on right on the flash itself. Press the Mode button on the back of the flash, so that ETTL is displayed in the LCD, then press the High-Speed Sync button until you see its icon (a lightning bolt with an H) appear next to ETTL. That's it! There are downsides to shooting at high sync speeds like this, though: (1) it drains your batteries much faster, and (2) the power output from your flash goes down quite a bit.

Don't Have a Gel? Change Your White Balance

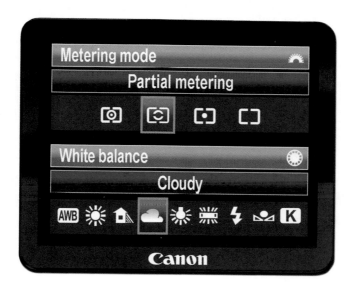

If you're shooting outdoors, and you don't have a gel to put over your flash head (to make the color of the light coming from the flash look more natural, instead of bright white, which looks like studio light outdoors and just looks weird), try this instead: change your camera's White Balance setting to Cloudy (on a Nikon, from the Shooting menu, choose White Balance, then choose Cloudy; on a Canon, press the White Balance Selection button, then turn the Quick Control Dial and select Cloudy). This gives your image an overall warm feel, and it helps make the light from your flash look warmer, too! Give it a try the next time you're stuck for a gel—it works better than you'd think.

Put Nikon's Commander Mode One Click Away

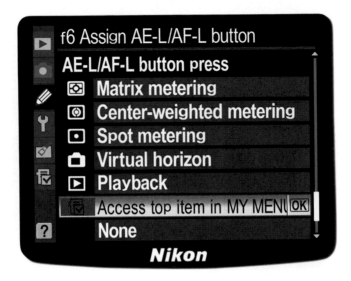

This is an incredibly handy tip I learned from David Tejada. It's for photographers who are triggering one or more Nikon hot shoe flashes using the built-in pop-up flash on their DSLR. (*Note:* If you have a Nikon D3 series camera, you don't have a pop-up flash, so you'll need to buy a Nikon SU-800 transmitter, which slides into the hot shoe on top of your camera, or an SB-910 hot shoe flash to trigger your other flash[es].) These folks are controlling the power of each flash using the camera's built-in Commander mode. The problem is getting to Commander mode is kind of a pain (you have to dig a few menus deep, and even if you put it in your My Menu options, it's still a few buttons away). That's why this tip rocks—you can have it so your Commander mode options appear instantly by pressing one button on the back of your camera. It just takes a one-time setup and here's what you do: press the Menu button on the back of your camera, choose My Menu (where you put your most frequently used menu items), then choose Add Items and add Commander mode to your menu (it's found under the Custom Setting Menu, under Bracketing/Flash, under Flash Cntrl for Built-In Flash). When you add Commander mode to your My Menu, it puts it at the top of your My Menu list. Now, go back to the Custom Setting menu, go down to Controls, and choose Assign AE-L/AF-L Button. Toggle over to the right (press the right side of the multi-selector on the back of your camera), select AE-L/AF-L Button Press, then choose Access Top Item in MY MENU, and click OK. Now, when you press the AE-L button on the back of your camera, the Commander mode settings appear on your LCD. How sweet is that!

Making Your Flash Fire Every Time

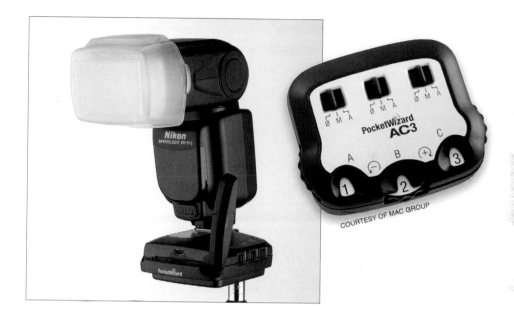

COURTESY OF MAC GROUP

I'm personally not a big fan of what they call "line of sight" methods for firing flash (where the only way your off-camera flash actually fires is if the sensor on the flash sees a pulse of light from one of your other flashes). The reason I don't like this method is because it doesn't work consistently. Well, it works fairly consistently if your flash has a clear, unobstructed view of the other flash, but in real life, that often isn't the case (now, if you're thinking, "But, I've seen Joe McNally do that," that's not a fair defense for two reasons: [1] we're not Joe McNally, and [2] Joe is a magical unicorn of off-camera flash, and I think his flashes fire simply out of respect, fear, or both). Anyway, to keep from pulling out your hair on location, I always recommend using a radio wireless remote, which pretty much always works (even if it's hidden from view, and even if it's 200 feet away from you). However, using just standard wireless units, like the PocketWizard Plus II, you can only wirelessly fire your hot shoe flash—you can't control the power settings (which is the one big advantage of the built-in, line-of-sight method—you can control each flash's power separately). PocketWizard, though, introduced a new, small, radio wireless controller called the AC3 ZoneController, which lets you not only fire, but control the power of up to three flashes individually (it's the dream baby—the dream!). Just so you know, you need the AC3 unit, which sits on the hot shoe mount on top of your camera and controls everything, and then you need a receiver (like the FlexTT5 Radio Slave Transmitter) on each wireless flash you want to use (I didn't say it was cheap, I said it was "the dream").

Creating a Tight Beam of Light

When we're using studio lights, and we want a tight beam of light (maybe we're doing something dramatic, with just a hint of light for our main light, or we want to have a crisp edge light behind or on the side of our subject), we don't use a softbox, we just use a reflector (like a beauty dish) and put a round metal grid over it and it creates a straight, focused beam of light aiming right at our subject. We can now do the same thing with hot shoe flash using a Rogue 3-in-1 Honeycomb Grid. You attach the included tube-shaped strap around your flash head with Velcro, then a round plastic grid holder inserts in the end (as seen above), and you get the same type of direct beam of light we get with studio lights. It works amazingly well. It's very lightweight, and since it comes with three different size grids (I generally use the 25° grid myself), you can choose precisely how tight of a beam you want (the lower the number, the tighter the beam, with 16° being the tightest one). They're from a company called ExpoImaging and they cost around $50 for the set of grid inserts, the tube-shaped strap, and the grid holder.

How Pros Deal with the Power Drop of High-Speed Sync

If you're going to be shooting in High-Speed Sync mode (see page 28), your flash power goes down, so its light won't travel nearly as far. That's why a lot of pros use a bracket that holds three (or more) flash heads (each flash only adds around 1 stop of light). Lastolite makes one, the TriFlash Shoe Mount Bracket, for around $80.

The Advantages of Using Flash in Daylight

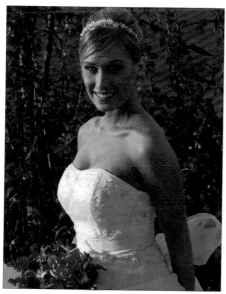

Without Flash

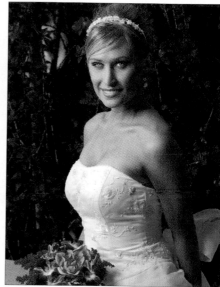

With Flash

A lot of people ask the question, "Why would I use a flash outdoors in the first place?" The simple answer is that it usually looks better, but there's more to it than that. First, you don't have much control over the position of the sun, and oftentimes it's in the worst place possible—right overhead. By using flashes outside, you get to create directional light, unless it's sunset, which is generally prettier light, although you may need flash to fill in a little. Plus, you get to use the sun as your backlight, lighting your subject's hair and giving you a beautiful rim light around them (just position your subject so the sun is behind them, if at all possible). Flash offers another benefit over using just a reflector outside, and that is your subject won't be squinting, like they usually do if you light them with a reflector and send a constant beam of sunlight back at their face.

Another Way to Deal with the Dark Gradient Shooting Higher Than 1/250

If you shoot at higher than 1/250 of a second and you see that dark gradient appear on your image, remember you can crop it away later in Photoshop. That way, you don't lose any power, and you don't drain the batteries as fast on your flash. Hey, I'm just sayin'.

How to Use Your Hot Shoe Flash's Modeling Light

Most studio strobes have a built-in modeling light—a continuous light that stays on when you turn your strobe on. It gives you a preview of how the light will look when the flash fires, and in a dark photo studio, gives your auto-focus lens enough light to lock on and focus on your subject. Most hot shoe flashes don't have a continuous modeling light, but to help you aim (preview) your light, they can create a temporary modeling light of sorts. On a Nikon flash, press the Menu button, then use the Selector dial to scroll down to Flash/Modeling (the icon looks like a lightning bolt and a person), and press the OK button. Scroll to Modeling and press OK again. You fire it (sending a series of very fast flashes, almost like a strobe, at your subject) by pressing the Test Firing button on the back of the flash unit. For Canon flashes, you turn it on by pressing-and-holding the custom function setting button until its icon shows on the flash's LCD. Then, turn the Select Dial and select the Modeling Flash (Fn 02) function.

A DIY Modeling Light for Hot Shoe Flash

You could buy a tiny LED flashlight and tape it to the top of your flash head with gaffer's tape. That way, you could illuminate your subject enough to let you focus in dark conditions and give you a preview of where your light is aiming. Energizer has a tiny 3-mode LED keychain light that's around $10 on Amazon.com.

Keep Your Flash from Powering Off

Because hot shoe flashes generally run on AA batteries, most of them automatically go to sleep, by default, after a certain number of seconds if they're not being fired, which is great for saving batteries, but not for saving face. Because when you go to shoot your next shot a few minutes later, your flash doesn't fire (because it's "asleep"), which doesn't make you, the photographer, look very good to…well…anybody. I'd rather swap out the batteries at some point rather than constantly have to wake up my flash after it doesn't fire. You can turn the battery-saver (embarrass maker) function, called the Standby function, off on Nikon flashes (like the SB-910) by going under the custom functions menu, choosing the Standby function, and then choosing --- (the Standby Function Canceled option, which is the three dashes) from the menu, which turns the feature off. On Canon flashes, like the 580EX II, go to your flash's custom function 01 (C.Fn-01), and turn off the Auto Power Off setting. Now, turning this off will definitely cause you to go through batteries faster, so you may not want this feature turned off all the time, but at least now you know that when you need those puppies to stay awake all the time, you know just how to do it.

How Far to Place the Flash from the Umbrella

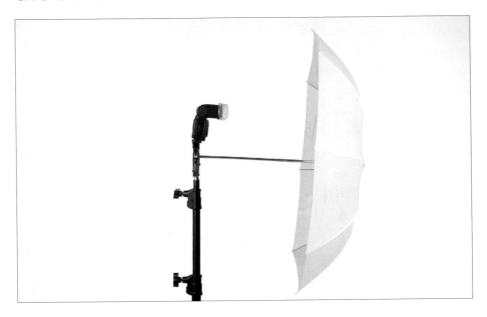

One question I get asked a lot by photographers using shoot-through umbrellas is, "How close do you put the flash to the umbrella?" This is a pretty reasonable question, because the umbrella's shaft can slide in/out of the swivel mount, and it's not really obvious where it goes. I always put my umbrella all the way out—as far away from the flash head as possible—for two reasons: (1) when it's far back like that, it will fill a larger amount of the umbrella with light, so my light source becomes larger, which makes the quality and softness of my light better, and (2) I don't get a big "hot spot" in the center of my shoot-through umbrella from the flash being too close to the umbrella. We want the light to spread out and get soft—not just concentrate in on the center.

How to Create a Broader Fill of Light with a Shoot-Through Umbrella

Once you have your flash in place, first make sure it's aimed at the center of the umbrella, but the tip is this: pull out the wide-angle diffuser (the clear one that pops out from the top edge of your flash) and put it over your flash head. This maximizes the spread of light from your flash to fill the umbrella, which gives you softer, better light.

Why Would Anyone Use Studio Strobes On Location?

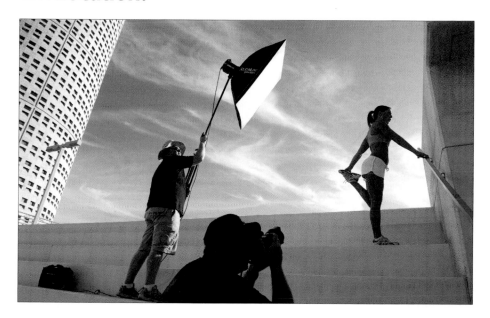

It's amazing what you can do with hot shoe flashes these days, and the accessories that you can buy these days give you near-studio-quality lighting on location. But if these hot shoe flashes are so great, why would anyone want to use studio strobes on location at all? Well, there are a couple of reasons, but one of the biggest is power. Believe it or not, these hot shoe flashes only put out around 50 watts of light, which is not a whole lot. They're ideal indoors, or at dawn or sunset, but when you need power, that's when you need studio strobes. For example, a low-powered studio strobe would put out at least 250 watts, with a standard strobe output at around 500 to 600 watts, so power is definitely an issue (especially if you're shooting outdoors in daylight, which is where many pros switch to studio strobes with battery packs). Another reason why studio strobes are popular on location is that you can take the same accessories you're used to working with in the studio out on location. The ability to have continuous modeling lights is a nice plus, but another big reason is the refresh rate—how fast your flash is ready to fire the next shot. Studio strobes with battery packs refresh very quickly—almost as quickly as they do in the studio—whereas you're often going to wait longer (sometimes much longer) with hot shoe flashes to refresh for the next shot. Of course, both have their pluses and minuses, but I wanted you to at least have an idea when it's time to rent a studio pack to go on location, rather than relying on your hot shoe flash for every situation.

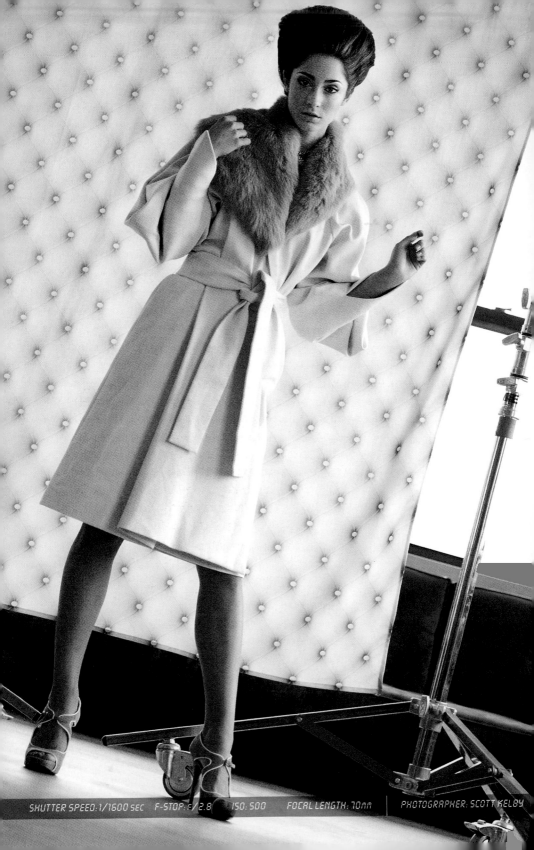

Chapter Three

More Tips on Using Your Studio Like a Pro

In Volume 3, We Took It Up a Notch. Now, Let's Do It Again!

If anybody had told me that, in this series of books, I would have three chapters dedicated to studio lighting, I would have told them that they needed to see a physicist. Now, you probably just read the last part of that line as "they needed to see a psychiatrist" (rather than a physicist, which is what I actually wrote) and that's probably because the human brain is pre-programmed to mentally insert words into sentences that reveal what we think we really need (a psychiatrist), rather than what I think you need (which is a really large softbox). For example, on some subliminal level, you must have repressed feelings of triggering inadequacies, but that's only because you have an unconscious desire to buy multiple wireless flash transmitters, which most likely stems from the fact that when you were a child your parents obviously denied you the right to assign your strobes to different groups and channels. This is surprisingly common these days, so I don't want you to think on any level that (a) you understand what all this is about, or (b) that I have any idea what this is all about, because clearly I don't know you well enough to be your therapist. But, I do know this: if you're still reading this chapter intro, you definitely need the professional help of a physicist. See, you did it again, you thought I said "psychiatrist." Maybe we should move straight to a word association exercise, which I think may reveal a lot about your inner psyche. When I say a word, you say the first word that pops into your head. Ready? *Pizza*. "20° round grid." *Salad bowl*. "Beauty dish." *Wide-screen TV*. "Strip bank!" *Savings & Loan*. "Octabank!" Hmmmm…I dunno, these seem pretty normal to me. But let's try one more just to be sure. *Declaration of Independence*. "Seamless paper." Yup, you're fine. Now tell me about your mother.…

The Pro Trick for Creating Falloff

As you probably learned in one of the other books in this series, the human eye is drawn to the brightest thing in the image, and in portraits of people, the brightest thing should generally be their face, right? The problem is that your softbox doesn't know that, and it will light their face, shoulders, chest, stomach, and so on, all with pretty much the same brightness. So, what we need to create is falloff, where the light literally falls off in brightness, so their face is the brightest thing in the image, then their shoulders are a little less bright, then it gets darker and darker as it moves down their body (unless you're shooting fashion, where the clothes they're wearing are equally as important, and maybe more so, as the person's face). An easy way to create this falloff is to block the bottom ¼ to ⅓ of the softbox. You can do this with anything from a large black piece of posterboard you buy at any craft store to a photographic flag (I use the ones from Matthews, which can easily mount on a boom stand). You just put it in front of the bottom of the light (as shown here) to cut the spread of the light and create that falloff. (*Note:* You'll also hear a photographic flag referred to as a "gobo," which is a Hollywood movie lighting term that is short for "go between," as in you've put something between the light and your subject.) By the way, one of the biggest mistakes people new to studio lighting make is to light everything evenly or to over-light the subject, so by creating this simple falloff, your shots will already look more professional.

Getting a Different Look Without Moving the Lights

Once you've got your lights in place and you've got that first shot in the bag, try this: Don't move the lights. Don't move your subject. Instead, leave everything as is and move the photographer (kudos to Jeremy Cowart for this tip). If you were standing right in front of the subject, just move way over to one side or the other and take the shot again. You'll be amazed at how moving two or three feet in either direction can completely change the look of the lighting, even if you haven't touched a single light. Give this a try and you'll wind up with two or three lighting looks out of just one lighting setup.

Using Lens Flare as an Effect in the Studio

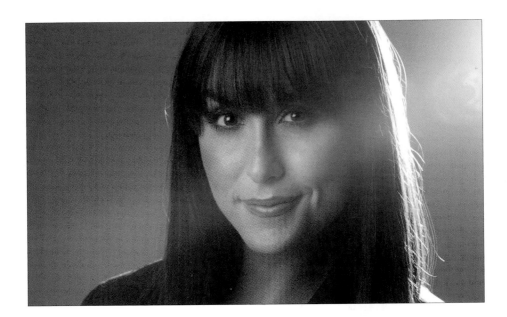

The blown-out, lens-flare look is really hot right now (it's that look where your image is intentionally overexposed and has a large lens flare visible in the shot). Luckily for us, it's fairly easy to nail this look—there are just a couple of tricks you need to know. The first is to take your lens hood off your camera. One of the reasons why we have a lens hood on in the first place is to eliminate lens flare, so we surely don't want that on our camera, eliminating the thing we actually want. Secondly, you're going to need a light behind your subject, and then you'll need to shoot from an angle that allows the beam from that back light to hit the face of your lens to some extent. (*Note:* If you have a fabric egg-crate grid on your softbox, or a metal grid on your strobe, make sure you take it off, because besides just focusing the beam, those grids actually help eliminate lens flare, so in this one case, they're working against you.) The key is finding the right position for your camera to maximize the effect coming from your strobe in the back, so it might take a few tries to get it to look right. By the way, today's higher-end lenses often have a special nano-coating on them designed to eliminate lens flare, so if you're struggling to get this look, try using one of your older lenses and that should do the trick.

How Far Should Your Subject Be from the Background?

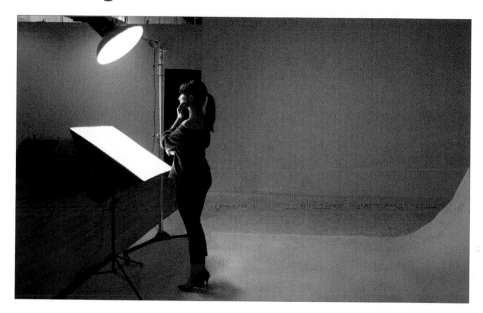

As a general rule, I try to put my subject about 8 to 10 feet from the background (unless I'm using my main light to light the background). Here's why: by keeping them far away from the background, you avoid your front light spilling onto the background. That spill-over generally looks pretty bad, and a lot of times it's not real obvious what the problem is—your photo just doesn't look right—so it's best to avoid that problem altogether. Another advantage of keeping that distance between your subject and the background is this: if you do want to use a separate background light, the two lights will be very distinct in the final image (it won't all mush together), which will help create the separation and depth you want by lighting the background separately. One last advantage is you won't have to worry about your subject's shadow falling onto the background, and if your subject is far enough away from the background like this, you can have your white seamless paper turn black (if no light is hitting it at all, it'll go just about solid black, because it's that far away from the front light). Now, what if you're shooting in a tight space and you can't get your subject 8 to 10 feet from the background? In that case, move your main light in really close to your subject. As you move it in closer, the main light gets brighter (and the light falls off to black much faster), and you'll have to change your aperture, so your subject doesn't look like you just tossed a lighting grenade in their face. So, if you were at f/8, change it to maybe f/11 or f/14, and the front light won't affect your background very much, if at all.

Let Your Main Light Do Double Duty

I always talk about how much you can get out of one light, and if you only have one light, you can have it pull double duty by having it light your background, as well. The trick is to move your main light close enough to the background so that it actually lights it for you. I do this a lot when I'm shooting on a white seamless paper background. If you don't put a lot of light on the white paper, it looks dark gray in your photo. If I'm shooting fashion, I generally like a light gray, so to get that dark gray to turn to light gray, I just move my main light closer to the background and the spill from it winds up lighting the background quite a bit. Just be sure to position your light up high and have it aim down at your subject. That way, your subject's shadow will appear near the floor, instead of casting on the background. It's a handy tip to keep in mind when you're using just one light.

Frank Doorhof's Words of Wisdom About Using One Light

My friend, and studio lighting wizard, Frank Doorhof has a great saying he shares with his students. He tells them: "When you think you need two lights, use one light. If you think you need three lights, use one light. If you think you need four lights, maybe then you might consider a second light." He makes a really great point—if you can use just one light, chances are it's really all you need. The more lights you add, the more complicated things get, the longer it takes, and the more problems and challenges arise.

Rim-Light Profile Silhouettes Made Easy

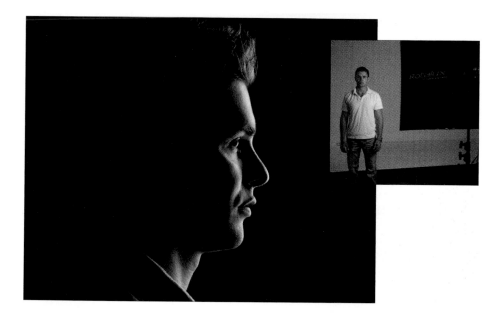

This is one of those super-quick, 30-second tricks that have a big impact. First, aim your softbox sideways and have your subject stand directly in front of the center of it (facing your camera). Now, have them turn sideways toward the softbox, so they're facing it directly. Next, have your subject take a step or two sideways, closer to you (while you're at your camera position). Have them step sideways toward you until they have actually moved past the edge of the softbox (so there's no softbox in front of them at all. It's actually a foot or so behind them, from your vantage point at the camera). Now take your shot. What you'll get is a strong rim light all the way around the profile of your subject, and the rest will appear as a black silhouette. If you want a little light to appear on the cheek facing the camera, have them move just a few inches back toward the light until you see that cheek lit just a tiny bit (this is where the modeling light comes in handy, because you can see a preview of how the light will fall).

Using a Ring Flash

Part of the ring flash look is that you clearly see the black halo shadow it creates around your subject, but if you don't have your subject really close to your background (which breaks all of our other background rules), you won't see that halo. So, when you're shooting with a ring flash, the trick is to get your subject just a few inches from the background and that black halo shadow will appear (as seen above).

Charge 'em Right Before You Use 'em

Nickel-Metal Hydride (NiMH) batteries discharge around 10% of their battery life per week if they're just sitting around doing nothing, so don't charge up your batteries until you need 'em for a job. That way, they'll be at full capacity.

Use Almost Any Softbox You Want with Your Brand of Strobe

A lot of folks may not realize that if you have a particular brand of strobes, you don't have to buy the same brand of softboxes. That's because you can often buy an adapter that lets you use a different brand of softbox with your strobes. For example, F.J. Westcott sells adapters, so you can use Westcott softboxes with just about any strobe brand out there, and they're in the $30 range. If you have Profoto strobes, but want to use softboxes made by Elinchrom, you can buy an adapter ring from Elinchrom that lets you do just that. So, in short, you can probably use just about any softbox brand you want, with just about any strobe you want—you're just an adapter away.

The Tethering USB Cable That Came with Your Camera Is Too Short

Luckily, you can buy a 10-foot USB extension cable that lets you plug your short USB tether cable into this extension, so you can shoot without constantly worrying about yanking your cable right out of your computer. You can find these at B&H Photo, or on Amazon.com.

When It Comes to Softboxes, Bigger Really Is Better

If I could give you just one tip about getting really beautiful light, it would be this: use the biggest softbox you can. Really big softboxes have gotten so popular lately because the bigger the softbox, the better the light, and today's lighting manufacturers have embraced this big time, so we have lots of choices. So, how big is big enough? My most-used softbox is an Elinchrom Rotalux 53" Midi Octa, because it's pretty big, but not so big that it dominates the room if I have to take it on location (which I often do). If you have a really high ceiling, you might look at something like the Elinchrom 74" Octa Light Bank (which is amazing!), but you don't have to spend a fortune to have a huge softbox these days. F.J. Westcott just introduced a series of huge 7' parabolic umbrellas— you can either fire a strobe into them (and the light gets huge and travels back toward your subject) or you can buy their shoot-through parabolic, where your flash fires through the umbrella (rather than reflecting off it). These are pretty darn affordable (well, in the context of lighting, anyway) at right around $100. If you want a more traditional softbox (the light is easier to control with softboxes versus umbrellas, so I tend to use them more often), then check out Westcott's 54x72" shallow softbox (it's huge and totally gorgeous and costs around $329). Are you seeing a pattern here? Yup. Big softboxes rule, and it makes getting beautiful portraits that much easier, and anything that makes getting great shots easier gets my vote.

What to Do When You Can't Turn Your Strobe Power Down Any Further

I mentioned on the previous page that the bigger the softbox, the softer and more beautiful the light. But what if you want even softer light? Well, the trick is to move that light as close as possible to your subject (without it actually appearing in the frame), because the closer the light, the bigger it becomes, which makes it even softer and more beautiful. One other thing happens when you move a light in this close: it gets much brighter (which makes sense, right? You move a light closer to something, and it gets brighter). So, as you move the light closer to your subject, you'll need to lower the power of your strobe so it's not so bright, right? Right. Now, what happens when you've lowered the power of your strobe as low as it can go (which is 2.3 on the BXRi 500 shown above), and it's still too bright (this happens to me quite often, because I usually position my softboxes very close to my subject)? When this happens to you, here's exactly what to do: raise your f-stop. That's right. If you were at f/8, raise it to f/11. If you started at f/11, raise it to f/14. This cuts the amount of light falling on your subject, so you get the best of both worlds—you're still getting super-soft light by moving it close to your subject, but you're not blowing them out with too much light because it's so close. You might even need to increase your f-stop by two stops or more, but if that's the case, don't sweat it—just do it.

How to Light a Couple or Small Group

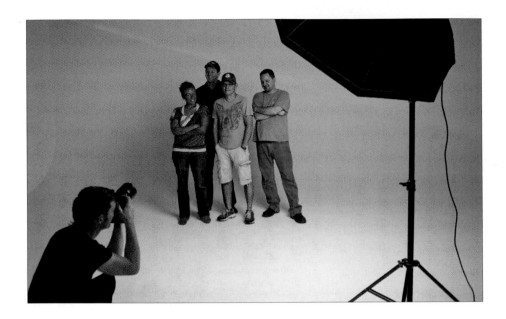

Lighting a couple or a small group is surprisingly easy, and you can do it with just one light and a large softbox, as long as you follow one simple rule: pull the light back fairly far from your subjects. If the light is too close, the person closest to the light will be brighter than the person standing next to them, and so on. Your goal is to have consistent, balanced light throughout the group, and the trick to that is to move your light way back. That way, the light pretty much hits the group at the same intensity, and the light looks balanced (just remember that moving the light farther away from your subjects makes the light darker, so you'll have to crank up the power on your strobe to make up for that). Another helpful tip is to position the light fairly near the camera position (not way off to the side) or you'll have shadows casting across people in the group. You will want the light off to the side a bit, just not way off to the side. You can even position the softbox directly behind you as you shoot (if your head sticks up a little in front of it, don't sweat it), and that will do the trick, too. (*Note:* If you're thinking, "Hey, won't moving the softbox back farther make the subjects smaller in relation to the size of the softbox, so the light won't be as soft?" you're right, which is why you want to use a very large softbox for shooting groups. That way, when you move it far away, it's still big, so the light is still soft.)

The Trick to Staying Out of Trouble

When I see photographers who are new to studio lighting really struggling, it's generally when they're using multiple lights and something looks wrong, but they don't know exactly what's wrong—but it's definitely something. No matter where they move the lights, it just gets worse. This is generally because they put the lights in position and turn them all on. This is a recipe for disaster. The trick to staying out of trouble is this: only turn on one light at a time. Get the brightness right (the power setting), get the light properly aimed, and get the position right. Once that one light looks right (here's the secret) turn *off* that light. Now, turn on another light (maybe a back light). Get just that one looking right (while no other lights are turned on), then once it looks good, turn that one off. If you're using a third light, turn only it on, and get it right. Now, turn them back on, one by one, starting with the back light. As you add a light, pause and take a look at how things look. Take a test shot with just the back light on, or just a hair light, or both, and see how it looks. If it doesn't look good by itself, turning on a bunch of other lights surely won't help. The secret to success with multiple lights is to get each individual light looking good by itself. That way, when you finally turn them all on, they will complement each other and work together, rather than just throwing a bunch of random lights everywhere. It takes a few more seconds up front to set each light and position it individually, but it will save you loads of frustration and aggravation along the way, plus you'll wind up with better lit photos, guaranteed.

Where to Put Your Softbox Demystified, Part I

When I was on the road with my *Light It. Shoot It. Retouch It. LIVE!* seminar tour, one of the most-asked questions was "Where do I put my main light?" People were really confused and apprehensive about it, and if you've ever felt like this, I've got good news for you (and it's something you've probably never heard before). First, you already know that your strobe will be up high on a light stand, aiming down at an angle (kind of like the sun aims down on us). With that in mind, the secret is that there are basically two places your front main light goes: either (a) directly in front of your subject, or (b) at around a 45° angle to them. Are there other places you can put it? Absolutely. Where do most pros wind up putting it, no matter whether they are in the studio or on location? In front or at around a 45° angle (by the way, more often than not, it's at around a 45° angle). Pick up any book on lighting, check out all the diagrams, and see for yourself—diagram after diagram will bear this out. No matter how intricate the set they're shooting on, no matter how many lights they have in the back or how they're lighting the background, their front light is almost always in one of these two places. Now, if they have a light behind their subject, guess where it winds up most of the time. (Wait for it…wait for it….) Either directly behind their subject, or behind them at a 45° angle. I know you were hoping it was more complicated than that, but it is what it is. So, the next time you're sweating about where to put your main light, if you put your light either directly in front of your subject, or at a 45° angle to them, just know—everybody else is pretty much doing the same thing.

Where to Put Your Softbox Demystified, Part II

Okay, let's say you chose the 45°-angle-to-your-subject lighting setup. Now what? Well, while that 45° angle is the right basic position, as you move your light even just a few inches in either direction, your lighting will change, so this is where you really massage your light to make it exactly what you want it to be. Picture an overhead view of your lighting setup and that the setup is the face of a clock, where your subject is in the center of the clock. The standard 45° angle is #2 above, but if you want more or fewer shadows on the opposite side of your subject's face, then you just rotate the light "around the clock." For example, the #1 position is more in front, and will light more of the face, so your subject will have fewer shadows on the far side of their face; #3 is more to the side, and they'll have lots of shadows on the other side of their face; and #4 is literally lighting their side, and the other side of the face will be totally in shadow. Now, which of one these lighting setups is correct? The one you choose, because they're all correct—they just have different amounts of shadows. When shooting a man, I tend to like #3 and #4. For a woman, I tend to like #1 and #2. But, I've used all four on both men and women, so it's really up to you. Just remember this: in all four of my examples, the subject is facing forward. If you want more light to fall on their face for any of these positions, just have them angle toward the light (called "playing to the light").

Let Lightroom Fix Your Color as You Shoot

If you shoot tethered in Adobe's Lightroom application (going straight from the camera, directly into your computer, so you can see the images appear at full-screen size on your monitor as you shoot), then you'll love this trick, which lets you color correct one photo and has Lightroom's tethering feature do the rest for you automatically. Start by handing your subject a gray card and ask them to hold it up near their face (you can buy a gray card at any photography store, or if you have my *The Adobe Photoshop Lightroom Book for Digital Photographers* or my *The Adobe Photoshop Book for Digital Photographers*, look in the back of the book—I've included a perforated gray card for you, so just tear it out and you're ready to go). Once your subject is holding the card clearly in the frame, take a shot. Now, go to Lightroom's Develop module, get the White Balance tool (it's in the top-left corner of the Basic panel), and click it on the gray card. That sets the white balance for this one particular image (you're almost there). Next, go to Lightroom's Tethered Capture window (shown above), and from the Develop Settings pop-up menu, choose Same as Previous (also shown above). Now, when you take the next shot, it will automatically apply whatever you did to the previous photo. Well, you fixed the color (white balance) of the previous photo, so it will automatically do the same thing—it will fix the white balance for every photo as it appears. How handy is that? You only have to do this gray card trick again if you change the lighting pretty significantly.

How to Set a Custom White Balance In-Camera

If you'd prefer to set a custom white balance in-camera (rather than having Lightroom correct your white balance for you, as shown on the previous page), I would recommend using something like an ExpoDisc, which is a white balance tool used by a lot of pro photographers. Here's how it works: You start by putting the ExpoDisc over the end of your lens (it looks like a thick lens filter) and switching your lens to Manual focus (if you don't, your camera might not let you actually take a shot). Then, aim it at the light source (not at your subject—aim it directly at the main softbox you're using) and take a shot. Now, in your camera, you're going to assign that image you just took as your white balance reference image. Here's how: On Nikon DSLRs, before you take the shot, hold the WB button, then turn the dial until your White Balance is set to PRE, then release the WB button, and press it again until the letters "PRE" start blinking in your LCD panel on the top of your camera. That's your cue to take your shot (you have 10 seconds to take it), so aim your camera at your softbox and fire off a shot. You should now see GOOD appear in the LCD panel. That's it—your custom white balance is set (don't forget to turn your lens back to Auto focus, though). On Canon DSLRs, put the ExpoDisc over the front of your lens, aim at your softbox, and take a shot. Now, press the Menu button on the back of your camera, scroll down to Custom WB, and press the Set button to bring up the next screen, then press Set again to choose that shot you just took as the white balance reference photo. Lastly, press the White Balance Selection button on top of your camera, then rotate the Main dial until you see Custom WB appear in the LCD panel (don't forget to turn your lens back to Auto focus).

Taking Your Existing Strobes On Location

If you want to use your studio strobes on location, all you need is a way to power them by battery, since you probably won't be able to just plug them into a wall socket. You used to have to buy specialized strobe heads that only worked with a proprietary battery pack, but in the past couple of years, we've seen battery packs appear where you can just plug a standard 120v household-style plug right in, which means that now you can take your existing studio strobes just about anywhere. I've been using a very small, very convenient, very lightweight pack called the Paul C. Buff Vagabond Mini Lithium, and it works pretty darn well (it's reasonably inexpensive in the context of studio lighting, where nothing is actually reasonably inexpensive). You can pick one up for around $239 (direct from www.paulcbuff.com). It has two 120v outlets and a rechargeable battery that charges in about 3 hours—you get around 200 full-power flashes per charge. Now, the important phrase there is "full-power" because, unless you're shooting out in direct sunlight, you probably won't need to be firing these strobes at full power (more likely, half power or less), so if you fire at a lower power, you'll get a lot more flashes out of each battery charge. A lot more!

Chapter Four

More Tips on Lenses

Going Way Beyond Which Lens to Use

When you look at a camera body, you can understand why it's so expensive. After all, it's got a built-in computer (that's why it has a screen, and tons of menus you can navigate through, and you can set it up so it performs a bunch of tasks automatically, just like any other computer), so it kind of makes sense why it's so expensive. But lenses don't have any of that stuff. There is no computer. There is no screen. There are no menus. Besides being different lengths, they all pretty much look like they did 50 years ago, so you can't say they've spent a ton of money on looks. At the end of the day, it's a black tube with a round piece of glass on the end of it. Last time I checked, black tubes aren't very expensive, and a whole bunch of glass will only get you around 10¢ if you recycle it, but take that glass and put it on the end of a black tube, and it suddenly costs like $1,800. I mean, seriously, how can this be? So I did some research into this, and although this has been a closely guarded secret within the industry for many years, I'm here to blow the lid off the real reason lenses are so expensive today. Apparently, there is a "lens cartel" operating out of an undisclosed location deep within Cheyenne Mountain in Colorado and, by carefully manipulating the distribution and production of lenses, they are able to keep the prices of these lenses sky high. They are, however, apparently very concerned about a Russian lens cartel, and their fear is that the Russians might try to fly vast shipments of underpriced lenses in through Canada and across the U.S. Border, where they would release these lenses to U.S.-based camera stores. To counter this, they have created a sophisticated tracking system, with a bunch of expensive monitors (using satellites abandoned by the U.S. military), but I was able to crack this system using just a 2,400-baud modem and a "back door" password named after the reclusive professor's son who created all this. It was way easier than I thought.

Why Your Background Is Still in Focus at f/2.8

You've probably heard by now that if you want to put the background behind your subject out of focus, you choose a "wide-open" aperture setting like f/4 or f/2.8, but there's something they're not telling you. For that to work, you actually have to zoom in somewhat on your subject. So, if you're using a wide-angle lens (like an 18mm, 24mm, 28mm, and so on), even at f/2.8, unless your subject is really, really physically close to the lens, you're not going to get that out-of-focus background you're looking for. So, to get that soft, out-of-focus f/2.8 or f/4 background you're dreaming of, switch to a telephoto lens, and know that the tighter in you are, the more out of focus the background will appear. So, at 70mm, it's going to look a little blurry. At 85mm, even more so, as long as you're fairly tight in on your subject—move back 10 feet from your subject, and you lose it. At 120mm, you're getting nice and blurry backgrounds when you're zoomed in, and if you zoom in tight at 200mm, that background behind them is blurry city.

What You Need to Know About Lens Compression

42mm 210mm

You may have heard a lot of talk, especially when it comes to shooting portraits, about "lens compression" and how different focal lengths offer different types of lens compression. What this is all basically about is one thing: the background behind your subject, and how far away that background seems to be. For example, when you're shooting a portrait of somebody (or something, like the archway above, for that matter) at a wide angle, like 28mm or 35mm, the background behind them is going to look like it's waaaaaaayyy behind them (it actually exaggerates the distance between them). That's handy to know, because if you want to make it look like a huge sweeping scene with lots of depth between your subject and the background, shoot at a wide angle. However, if you zoom your lens to around 120mm and shoot the same subject at around the same size (which means you'll probably have to take a few steps back, since you just zoomed in), the background will now look quite a bit closer to your subject (even though your subject and the background are still in the exact same place). Now, zoom in even tighter on your subject (to around 200mm), and the background looks like it's even closer behind them. This is because when you zoom in tight like this, the compression effect the lens creates makes the distance between your subject and the background seem much shorter or more compressed. A lot of portrait and wedding photographers use this to their advantage because that compression also compresses your subject's facial features, which looks very flattering.

Seeing a Real Preview of Your Depth of Field

Unfortunately, when you choose an f-stop that would give you a really shallow depth of field, like f/1.8 or f/2.8, your viewfinder doesn't really give you a preview of how your soft, out-of-focus background will look. For you to really see how the background is going to look, you need to use your camera's depth-of-field preview button. This button is usually located on the front of your camera, close to the side of the lens. Press-and-hold this button and then look in your viewfinder and it gives you a much more accurate preview of how your image will look with the f-stop you've chosen.

Auto-Correcting the Fisheye Lens Effect in Photoshop

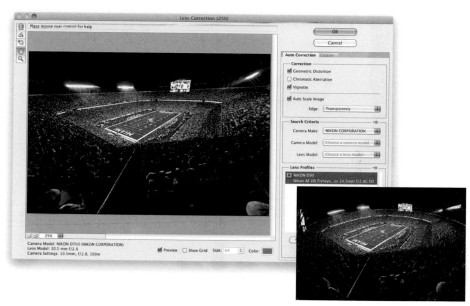

Before: Rounded

A fisheye lens is one of those lenses that you don't pull out very often (because a bunch of fisheye photos can get really old, really quick), but if you use them at the right time, they can be really fascinating. I use mine sometimes for cityscapes, or shooting in tight quarters, but mostly I use them for sports photography, where they look for sweeping shots of stadiums and indoor arenas, or I hold it up high over a group of players celebrating after the game, or I hold it down real low as the players take the field. Not everybody likes the rounding effect the fisheye gives, and if that sounds like you, don't worry—you can use Photoshop to automatically remove the rounding and leave you with what looks like a super-wide-angle shot, rather than a rounded fisheye shot. Just open the image in Photoshop, then go under the Filter menu and choose Lens Correction. When the dialog appears, click on the Auto Correction tab, and turn on the Geometric Distortion checkbox. The filter will look at the EXIF data embedded into the shot when you took it to find out what kind of lens you used, then it will automatically apply a correction that removes the "fishiness" and, instead, gives you that flat, super-wide-angle look. Now that you've learned how to remove the roundness, you'll probably find that some shots look better rounded and some look better flat, but at least now you've got two choices from just one lens.

Shoot at the F-Stop You Bought the Lens For

Fast lenses are pretty darn expensive these days (take a look at fast prime lenses, like the Sigma 85mm f/1.4 for Canon, which runs almost $1,000, or Nikon's 85mm f/1.4, a hugely popular lens with wedding and portrait photographers, yet it costs around $1,700). If you bought one of those lenses (or any fast lens, like a zoom that's f/2.8), you didn't buy it to shoot it at f/8 or f/11. You paid that money for the f/1.4, so when you pull out that lens, you want to be shooting it at f/1.4. That's the look, that's the f-stop, and that's the effect you paid for when you bought that expensive lens. So, make darn sure you're getting your money's worth by shooting it at the f-stop you bought it for.

How to Deal with Lens Fogging

The curse of the fogged lens generally happens to travel photographers who are shooting in warmer climates (which is generally where most people head for vacation—warmer climates), and it strikes when you leave your nice air-conditioned hotel room (or cruise ship cabin or car), and step out into the warm air, and your lens gets so fogged up that, for the next 20 or 30 minutes, it is unusable. There are two ways to deal with this: one way is to plan ahead to avoid the fogging, and another is what you do when it's too late (you're in fog town). We'll start with avoidance. The most popular way to beat the fogging up front is to put your lens in a clear, plastic Ziploc bag and store that bag inside your suitcase in your room, so it stays warm, and away from the air conditioning. Then you keep your lens in the bag until you're outside your room and ready to start shooting, and since your lens has been kept warm and sealed, it won't fog up when you put it on outside. If it's too late and your lens is already fogged, you can use a special fog eliminator cloth (a pack of three runs about $5, so go ahead and order them now, because by the time you need them, if you don't have them, it will be too late). Nikon actually makes their own brand of Fog Eliminator Cloths (you can find 'em at B&H Photo), but since all glass is made of…well…glass, I imagine they'll work just fine on Canon lenses, as well (just don't tell anyone they're made by Nikon. Don't worry—I'll keep it between us).

Avoiding Sensor Dust from Your Body & Lens Caps

When you take your gear out of your camera bag, what's the first thing you do? You take the cap off the body of your camera, and the rear lens cap off the end of your lens that connects to the camera (the mount). At that moment, you're holding two of the major sources of sensor dust, and what you do with them next can make all the difference between a clean, spotless sensor, or one that will soon have more spots than a Disney Dalmatian. I know a lot of photographers that will put those caps into their pants pocket, so they don't lose them (huge mistake, but at least you won't lose them), or they toss them back into their camera bag (so they can collect dust and junk there. Yikes), or hopefully, they'll put them in a zippered pocket in their camera bag (which isn't all that bad, but isn't great). Here's a great tip to keep junk (and lint, and other stuff) from getting in either cap: screw them together. That's right—turn the two caps so they face each other, and twist to screw them into each other. Now nothing gets in there. I'm still not sure I'd stuff them in my pants pocket, but now if I did, at least I'd feel a whole lot better about it.

How to Focus Your Lens to Infinity

If you're going to try to shoot something that's particularly hard to focus on (for example, let's say you're photographing fireworks, or a lightning storm way off in the distance [and by the way, that's exactly where you want to be when photographing lighting—way, way off in the distance]), then you can set your focus to a setting called "infinity," where every-thing way off in the distance will be in focus. To use this infinity focus, start by focusing on something visible a little way in front of you, then switch your lens to Manual focus mode (you do this on the lens itself—just switch from Auto focus to Manual). Now, turn the focusing ring on the lens itself (it's usually down closer to the end of the lens) all the way to the right (on Nikons) or all the way to the left (on Canons), until you see the infinity symbol (∞) appear on the distance scale on the top of the lens. Now you're focused out to infinity and things off in the distance will be in sharp focus, even if they're too far away to actually focus on (like the moon, or stars, or Justin Bieber).

Don't Shoot at the "Beginner" Focal Lengths

I hear from a lot of photographers who are frustrated because, compared to "everybody else," they think their shots look kind of "average." Now, consider this: if you're a beginner and you buy a new camera, chances are it comes in a kit with something like an 18–55mm lens (called a "kit lens," which is a very inexpensive, usually plastic, lens, which is generally not very sharp, lacks contrast and clarity, and so on). But let's put quality issues aside for a moment and think about this: your average beginner is going to take nearly all their shots in that 18–55mm range, right? So how do you keep your shots from looking "average?" One way is to avoid shooting with the kit lens, or at the very least, avoid shooting in that 18–55mm focal length or your shots will be at the same focal length as your average beginner. So, although I hesitate to tell you that "the secret to better-looking shots is to buy a longer, better-quality lens," because that won't do it alone, I can tell you this: it surely helps. You don't have to spend a lot on your longer lens (it can even be a used lens), but whatever you get will almost undoubtedly create sharper, higher-quality, and more contrasty images and you'll be out of that 18–55mm beginner's land.

If You Can't Afford Another Lens, Do This

If you can't afford a longer lens (although, check out Sigma's 70–300mm for around $170), and you have to shoot with the kit lens, stay at the 18mm wide-angle focal length, and avoid the 55mm length at all costs. So in short—go wide!

Where to Hold a Long Lens to Steady It

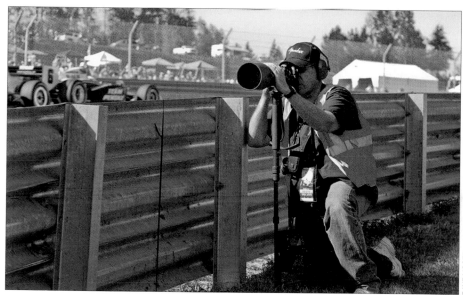

DAVE MOSER

If you're shooting with a long lens (like a 300mm or a 400mm), there's actually a place where you should hold the lens to help steady it while you're shooting, even when it's supported on a monopod. That spot is down at the end of the lens where the lens hood is. Your left hand gently rests on the end of the lens barrel (as shown above), which helps reduce the vibration and keeps your long lens steady while you shoot.

Which Lens for Outdoor Portraits?

There is no one lens for outdoor portraits, but if there is one lens that is really hot right now for outdoor portraits, hands down it has to be the Canon 85mm f/1.8 or the Nikon 85mm f/1.4. These lenses have a nice focal length for portraits, but the real reason everybody loves them is for the insanely shallow depth of field they provide (if you get your subject so they pretty much fill the frame, the background goes so soft and out of focus that you'll never want to shoot anything else). You hardly see a professional wedding or senior portrait photographer not shooting an 85mm to death right now, and the reason is it looks great and people (clients) love its almost cinematic look. The only downside is, of course, that since it's the lens that everybody wants to shoot, and since it does all this magical stuff to the background, it isn't cheap. It's a business investment (the Nikon 85mm f/1.4 sells for around $1,600, but the Canon 85mm f/1.8 sells for only around $400, so that's actually a pretty good deal). Also, don't forget about 85mm lenses from Sigma (for both Canon and Nikon), which many photographers swear by, and they're usually much less expensive than Nikon or Canon lenses.

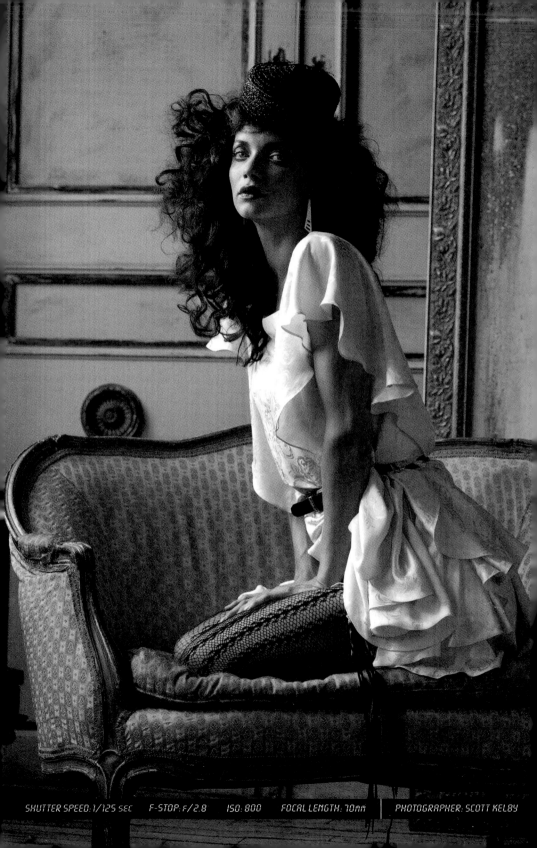

Chapter Five

Pro Tips for Shooting in Natural Light

How to Take Advantage of the Most Beautiful Light on Earth

You know what I like best about shooting in natural light? It's free. That's right, you don't need a wireless trigger, or light stands, or batteries, or gels, or softboxes, or any of the other stuff photographers lug around in Pelican cases, and that takes forever to set up, and then, invariably, doesn't fire, or doesn't fit, or you forget to bring it. Because, then, you wind up yelling at your assistant, but your assistant isn't really your employee—it's your friend that's just helping you out. And now you've gone and yelled at her, so you look like you're "in charge" on the set, and while that might be fine with an employee who is kind of paid to put up with your BS (belligerent shouting), she is actually someone you met at Applebee's when you were on your lunch hour, and your friend Mark knew her from when he worked at the mall. So, really, she's just helping you out to be a friend, and she's not even a real photography assistant at all, so you couldn't expect that she'd just somehow know exactly how high to put that light stand, because after all, she's a clothing designer, and what she really wanted to do was the styling for the shoot. But, here she is futzing around with a light stand, which was exactly what she didn't want to be doing on a Thursday afternoon, but now she's doing something she didn't want to be doing in the first place, and she's only there as a favor to Mark, who introduced the two of you, and you're yelling at her about something she has never been trained on. Now she's got tears in her eyes, because this whole thing reminds her of the time her ex-boyfriend wanted to take her jet skiing, but then he yelled at her when she untied the line, because he never told her when to untie it. So, now she's bawling and you're mad, and this whole thing could have been avoided if you had either: (a) shot in natural light or (b) eaten at Chili's that day instead.

Beautiful Backlit Shots

If you want to add some visual interest to your outdoor shots, look for backlight oppor-
tunities, especially when shooting people. Backlit images bring a drama and dimension
you don't often see, except from pros. How do they do it? First, position your subject
so the sun is directly behind them, with no light falling on their face, so they look like a
silhouette. Then, switch your camera's metering mode to Spot Metering, and aim your
focus point on your subject's face. By doing this, you're telling the camera, "This is the
most important thing in the photo—make sure it's properly exposed." Now, when you
take the photo, it will make your subject's face much brighter. The rest of the photo will get
brighter, too, but in most cases that's okay, because what's behind your subject is the
sun (which is usually pretty bright anyway). If you're shooting in aperture priority mode
(which is what I shoot in outdoors in natural light) and you think the entire photo is too
bright, back it off by using exposure compensation (where the camera makes what it
thinks is the proper exposure, but once you look at it, you disagree and want to override
that and make the photo darker or lighter). On a Nikon, hold the exposure compensation
(+/–) button on the top, and then move the command dial on the back to the right to either
–0.3 or –0.7 (you'll see this in the top control panel), and then take another shot (the whole
shot will either be ⅓ or ¾ of a stop darker). On a Canon, turn the power switch to the top
position (above On), look at the LCD panel on top, then use the quick control dial on the
back to override the exposure either –0.3 or –0.7, and then take the shot and see if you
need it darker—if it's too dark, try again.

Shooting Silhouettes

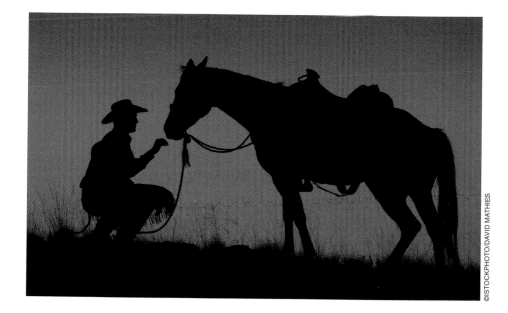

©ISTOCKPHOTO/DAVID MATHIES

Backlit silhouettes of your subject (whether your subject is a person or a flower, or a horse, or a cowboy, and so on) can look wonderful as long as the shape of your subject makes it instantly obvious exactly what it is. This is why subjects that are by themselves often work best. If two people are together hugging, a black silhouette of them some-times just looks like one big blob—you don't see them as two people hugging. As for your camera, the trick to getting great silhouette shots is to pretend your subject isn't there, and just shoot the scene like you were shooting a landscape shot (so I would shoot it in aperture priority mode, or you can switch your camera to landscape scene, if your camera has that). If you try to expose for your subject, your camera will try to properly expose for your subject (let's say it's a cowboy at sunset), and then it won't actually be a solid silhouette. So, just pretend you're there to shoot the sunset, and the rest will fall into place. Remember the trick—pretend your subject isn't there, and just shoot it like you would a landscape (with the sun behind your subject), and you're gold!

Jay's Trick for Not Missing the Shot

I learned this tip the hard way from my friend Jay Maisel, who is one of the living legends of American photography, as he showed me a shot he had taken while the two of us were walking around in downtown New York City one afternoon. I had the same shot. His was tack sharp. Mine wasn't. We had the same exact camera make and model. He asked me what ISO I was shooting at. I was at 200 ISO. He was at 1600 ISO (which means his shutter speed was fast enough to get a really sharp hand-held photo. At 200 ISO, mine wasn't). He chuckled at me and kept walking. I now shoot at 1600 when I'm walking around, because I'm not going to miss the shot next time because it's a little blurry. If you ever get the choice between a little noisy (from the high ISO) or a little blurry, choose a little noisy.

How to Make Sure Your Sunset Looks Dark

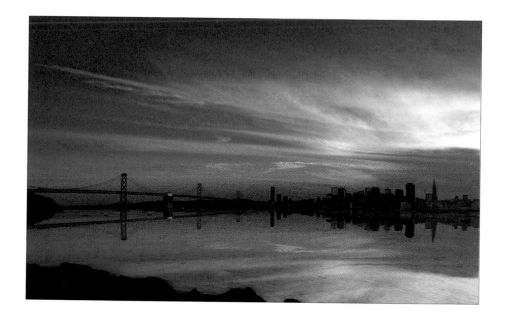

If you're shooting a sunset, it should look dark, right? But if you're shooting in aperture priority mode (that's the mode I shoot in when I'm shooting in natural light), or maybe programmed (or program) mode, your camera is probably going to try to make a "proper" exposure, because it doesn't really realize that you're trying to shoot a sunset, and you'll wind up with a sunset that's more like an hour or so before sunset. The trick is to force your camera to take a darker shot. You can do this using the exposure compensation trick I talked about on page 74 (about shooting backlit shots), or you can do this: Switch to programmed mode (on a Nikon; program mode on a Canon), aim at the sunset (focus on a cloud to the left or right of the setting sun, if possible), then press-and-hold your shutter button down halfway. Look inside your viewfinder and see what f-stop and shutter speed your camera chose for this shot (let's say it's f/8 at ½₀₀ of a second). Remember that setting (f/8 at ½₀₀ of a second) and switch to manual mode (don't freak out—this is easy stuff). Then, set your aperture to f/8 and your shutter speed to 200 (it generally doesn't say ½₀₀ of a second. It'll just say 200). Now, your job is to make the sky darker. Easy—just change your f-stop from f/8 to f/11 and voilà—your sky is darker than your camera would have taken in program or aperture priority mode, and your sunset looks great. If you want it even darker, try f/14 or f/16, and you'll see a rich, dark, beautiful sunset.

Tips for Using a Reflector Outdoors

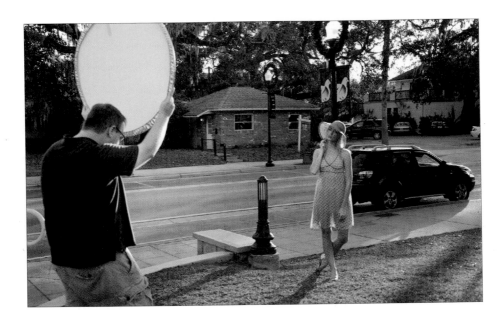

If you want your reflector panel to be your main light outdoors (bouncing the sunlight back toward your subject), then you need to position your subject so they're in the shade. Not deep in the shade, just near the edge of whatever you have them standing under. So, if they're standing under the overhang of a building, have them stand where they're almost out in the sun. If it's under a tree, don't let them get way under it—the best "shade light" is out near the edges of the tree. Now that they're in the right position, put your reflector in the right position. First, don't hold it down below them bouncing the light up into their face. This unflattering "up lighting" is usually reserved for Halloween, as it tends to make people look a bit creepy. Your job with the reflector is to mimic the sun, so hold it up high (over your head, or ideally, have your assistant hold it over their head) and tilt it so the reflected sun hits your subject from above. Next, when shooting outdoors, don't use a white- or silver-sided reflector—use a gold reflector, so your light doesn't look too white, like you took a studio strobe on location. Also, don't forget you can bend the edges of your reflector, so you don't evenly light your subject—if you just want to light their face, bend the bottom of the reflector up a bit, so it doesn't light their body. Lastly, if you're shooting right out in the midday sun, instead of using it to reflect light, use it to block the sun—put it right over the subject's head (the closer the better, but just outside your frame), so it's between the sun and your subject. Now, although you might have to raise your ISO a bit (to raise your shutter speed) to shoot in the shade of your reflector, at least the quality of your light is dramatically better.

Control the "Power" of Your Reflector

One of the handiest tools for controlling light outdoors is a basic $20 reflector. It's incredibly handy because it's lightweight, folds up to a small size, and most importantly, you don't have to plug it in, and its battery never runs out (well, since it doesn't have a battery). But, over the years, I've heard people say that the weakness of the reflector is that you can't turn the power up/down like you can with a flash. Well…that's only kinda true, because you actually can control the amount of light a reflector reflects onto your subject by how far away the reflector physically is from your subject. The closer it is, the brighter the reflected light becomes. So, if the reflected light is too bright, then just move the reflector farther away. What's a good distance for a reflector used outdoors to bounce some sunlight back into your subject? About 8 to 10 feet from the subject is a great starting place. If you want the reflected light brighter, move in tighter, as seen above. Easy enough.

How to Deal with Underexposed Daytime Shots

Here's a tip I learned from wedding photographer Cliff Mautner, who is an absolute genius when it comes to shooting outdoors in direct sun in aperture priority mode (which is what I recommend and use for shooting outdoors in natural light). If your subject is wearing light clothes (like a bride in a white gown, for example), your camera's meter is going to see all that brightness in the gown and adjust the shutter speed to make the shot dark (which will make your subject's face dark, especially if you have your subject positioned so the sun is behind her, which it should be, by the way—don't shoot people with the sun over your shoulder, the sun should be behind them). The trick is to override what the camera thinks the proper exposure should be (it thinks it should be dark) and use exposure compensation to increase the exposure by ⅓ or ¾ of a stop (or maybe even 1 full stop or more). Here's how it's done: On a Nikon, hold the exposure compensation (+/–) button on the top of your camera, and then move the command dial on the back to the left to either +0.3 or +0.7 (you'll see this on the top control panel) and then take a shot (the whole shot will either be ⅓ or ¾ of a stop brighter). On a Canon, turn the power switch to the top position (above On), look at the LCD panel on top and use the quick control dial on the back to override the exposure by either +0.3 or +0.7, then take the shot and see if you need it brighter. If your subject's face doesn't have enough light on it, increase that exposure compensation a bit more (to +1.0; a full stop), and take a test shot to see where you're at, and so on, until you nail it. So, in short, the trick is: if the scene is too dark, use exposure compensation to override the camera and then overexpose the image a bit.

The Trick for Shooting at Night

If you're shooting outdoors at night, one of the best tips I can give you is to not shoot with one of your camera's standard modes, like aperture priority (A on a Nikon or Av on a Canon), or any of the preset modes, like landscape or portrait. Those all work pretty well during the day, but shooting at night, and getting the night sky to be that really dark blue or black that you're seeing with your eyes, often isn't going to happen with one of those modes, because they'll make the whole image too bright. After all, your camera doesn't know it's night, so it's just doing its job of trying to make a proper exposure. That's why I feel that the real secret to shooting at night is to shoot in manual mode. To do that, you'll need to use the meter inside your camera's viewfinder (this is so easy to do, you'll be amazed, so don't let this freak you out one little bit). So, switch to manual mode and dial in a starting shutter speed (at night, you'll be on a tripod, so try something like 1/30 of a second to start). Let's also choose an f-stop to start with. How 'bout f/8? Okay, good. Now, look in your camera's viewfinder. On a Nikon, the meter shows up either on the far right or bottom of your viewfinder; on a Canon, it appears at the bottom of the viewfinder. There's a big line in the center of your meter, and then little lines that go above it and below it (or to the left and right). If you see lines above the line, it means that if you shot right now, your shot would be too bright (overexposed), so try moving your sub-command dial (or quick control dial), which chooses the f-stops, until you see those lines go away (which means—perfect exposure). Now, that may be correct (technically), but if that night sky isn't nice and black (or dark blue), keep turning that dial until it underexposes.

Shooting Light Trails

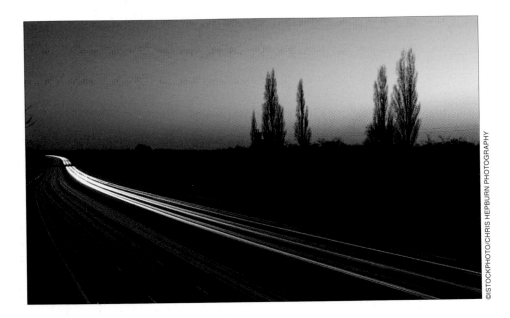

©ISTOCKPHOTO/CHRIS HEPBURN PHOTOGRAPHY

When I think of light trail shots, I always think of the light trails from cars driving at night, and they're easier to shoot than you might think. You just need a tripod and cable release (to keep everything from moving even a little bit while your shutter is open, and it's going to be open for a few seconds—long enough for the lights to move. By the way, the longer your exposure, the longer those light trails will be). Once your camera is on the tripod, and your cable release is ready to go, change your shooting mode to manual, then dial in an f-stop that makes everything in focus (like f/11), and then start with a shutter speed of 15 seconds (you may have to increase it a bit to 20 seconds or more, but this is a good starting place). Make sure your ISO is at its cleanest setting (for most Nikon DSLRs that would be 200 ISO, and for Canons 100 ISO). When you see a car coming into your view, just press your cable release, wait 15 seconds, then take a look at the image on your LCD and decide if you need to increase your shutter speed to 20 seconds or so (remember, longer shutter speeds mean longer light trails, so it's at least worth a try). That's pretty much all there is to it.

Where to Shoot Light Trails

One of the most popular, and interesting, locations for shooting light trails is a high vantage point—either on an overpass, or a bridge, or someplace where the cars are below you.

Shooting Star Trails

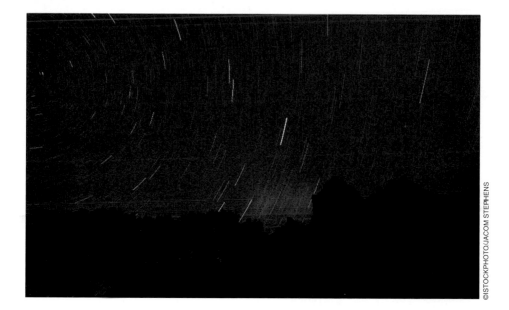

©ISTOCKPHOTO/JACOM STEPHENS

Start by choosing a clear night sky for shooting, far away from the lights of the city, and try to compose your shot so there is something low in the foreground (like the tops of mountains, or a silhouette of treetops, or even houses), and compose it so the moon isn't visible in the shot (its reflected light will mess up the rest of the shot). Next, you'll want to set up your camera (which should be on a tripod, with a cable release attached) facing north (use a compass or a compass app on your smart phone to figure out which way to aim), then find the North Star and put it in the center or on the very edge of your image. Set your lens's focus to "Infinity" by switching your lens to Manual mode (flip the switch right on the lens), then turning the focus ring on the camera all the way until you see the infinity symbol (which looks like this: ∞) on the top of the lens (that way, your lens doesn't try to refocus at some point, which would trash the image). Then, set your ISO to 200 (for Nikons) or 100 (for Canons) to get the cleanest image possible. Next, switch your shooting mode to manual, and set your aperture to as low a numbered f-stop as your lens will allow (for example, f/4, f/3.5, or f/2.8) to let as much light in as possible. Now, set your shutter speed dial to bulb mode (which means the shutter will stay open as long as you hold the shutter button down), then press the shutter button on the cable release, turn on the lock, and start your timer, then unlock at the amount of time you're willing to invest (no less than 20 minutes, but ideally an hour or more) and you're there! On the next page, we'll talk more about the gear you'll need for shooting star trails.

The Gear for Shooting Star Trails

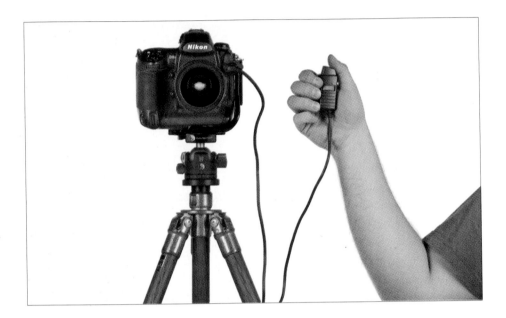

This isn't a lesson in shooting long-exposure images, this is a lesson in shooting really, really, really long-exposure images (like 1 hour or more). Because you'll need to keep your camera absolutely still for a minimum of 20 minutes, but probably more like an hour or more (the longer the exposure, the longer the star trails will be), you want to use a really sturdy tripod, and use a ballhead that won't slip even a tiny bit during that hour (or two or more). You're also going to need a cable release, so you don't have to stand there holding your shutter button down for an hour (a cable release can lock your shutter down for as long as you need). Also, depending on the time of year, and your location, it might get quite cold out where you're shooting, and you could get a frost buildup on your lens. Believe it or not, your exposure is so long that you can wipe your lens with a cloth and it won't affect the shot, so if frost is a possibility, you'd better bring along a clean cloth. If you do bring a small flashlight (it's going to be mighty dark out there), make sure you don't shine it into the lens when you're wiping away that frost—keep that far away.

Another Reason to Avoid Shooting at High ISOs

Today's higher-end cameras are getting better and better at shooting at high ISOs with very low noise, and today, with my Nikon D3S, I routinely shoot at 4000 ISO for nighttime or indoor sporting events, and people always comment that they can't see any noise. It's true. You can hardly tell there's any noise there at all, and what's there is absolutely minimal—less than shooting at 400 ISO on a film camera. So, if you can hardly see any noise at 4000 ISO, why do I hate shooting at 4000 ISO? It's because at 4000 ISO (or almost anything above 2000 ISO), you lose color saturation, your image has visibly less contrast, and you lose some detail, too. Sure, you don't have all that noise, but you don't have as good a quality photo as you'd have at lower ISOs. So, although sometimes to freeze motion under the lights, I have to shoot at 4000 ISO (to get my shutter speed to 1/1000 of a second), you can definitely see a difference in the quality of your image and that's why before you think, "Hey, I'll just bump the ISO way up," know that there's a bit of a tradeoff. It's certainly not unacceptable, but just so ya know—it's there.

Chapter Six

Shooting Landscape Photos Like a Pro

Yet Even More Tips for Creating Stunning Scenic Images

I think one of the most appealing things about being a landscape photographer is not only are you coming back with amazing photos, but you get to experience some of the best of what nature has to offer while you're doing it. I'll never forget this one time I was shooting in Montana's Glacier National Park. I got up around 4:15 a.m., so I could head out early and be in position for a dawn shoot. When I reached the lake overview, it was still pitch dark, and I remember setting up my tripod and watching it blow right over in the freezing wind that whipped off the lake. I just laughed and set it right back up, attached my camera gear to the ballhead, and realized that I'd better not let go of the rig or it, too, might blow over. I didn't want to give up my spot, because I had a pretty good vantage point (at least it looked like a good one in the dim moonlight). So, there I stood, out in the freezing, bitter cold, where each gust of wind was like a thousand knives jabbing right through me. I'm standing there shivering in the piercing cold, and then it started to rain. Not snow. Nope, that would have been pretty. It was rain. A driving rain that felt like a massive army of Lilliputians were firing their tiny arrows at me, but I just stood there in the bone-chilling cold like a wet, frozen statue, with my cracked, frostbitten fingers barely able to grip my tripod. I silently prayed for the sweet mercy of death to come upon me and relieve me of this frigid hostile misery. It was just then when I looked over and saw another photographer, who had just set up his tripod about 14 feet from me, slip on the ice that had formed on the overlook. I stood there and watched as he and his tripod, expensive camera and all, slid down the side of the embankment. I could hear him moaning for help, but I just couldn't stop smiling as I looked over and saw his Tamrac camera bag still up on the overlook beside me. I nearly pulled a muscle as I tossed his gear-laden bag into my rented SUV and quickly drove away, thinking to myself, "Man, this is what it's all about."

You Don't Need Fast Lenses for Landscapes

I've talked with a lot of folks over the years who think they need to buy really fast glass for shooting landscapes (lenses that shoot at apertures like f/2.8 or f/4). But, when it comes to shooting landscapes, this is the last place you'll get to take advantage of those fast apertures. In fact, you'll more likely be shooting at f/16 or f/22, which just about every lens out there already has. Plus, you'll hopefully be shooting on a tripod most, if not all, of the time, so your shutter can go as slow as it needs to go to make a proper exposure. Keep these things in mind when you're buying your next landscape lens, and you might be able to save quite a few bucks.

Three More Tips for Silky Waterfalls & Streams

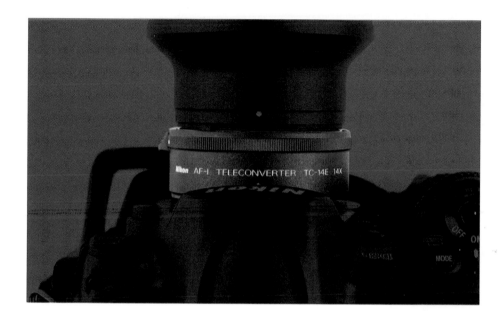

Back in volume 1 of this book series, I talked about setting your f-stop to f/22 to help you get a silky water effect when you're shooting waterfalls or steams. But, what if you set your camera to f/22 and you want the water to be even silkier? Here are three more things you can do to slow down your shutter speed even more (which is the secret to silky water—the slower your shutter speed, the silkier the water): (1) Add either a 1.4x, or ideally a 2x, teleconverter to your lens. These magnify the distance of your lens so you can get in a little tighter, but the tradeoff is you lose either 1 or 2 stops of light. Normally, you might think that's bad (and normally it is), but if you actually want to lose a stop or two of light, which we do because it makes the shutter speed longer, then it's a big win for shooting waterfalls and streams. (A big "Thanks!" to my buddy Moose Peterson for this tip.) (2) Use your lowest possible ISO (for example, some Nikons let you go below their native [cleanest] ISO setting of 200 to settings called Lo 0.3 or Lo 1, which are kind of like using ISO 100 and make your shutter speed slow down. Again, this is exactly what we want. You'll lose a tiny bit of sharpness and contrast at Lo 1, but you'll wind up with a slower shutter speed, which is good). And lastly, (3) put a polarizing filter on your lens. These are used to cut reflections in water and windows and stuff like that, and they're also used to darken the sky. But, for our purposes they do something equally important—they make us lose a couple stops of light, which (say it with me) slows our shutter speed even more and is exactly what we need to get really smooth, silky water. Add these three tips to your bag of silky water tricks.

Long Exposure B&W, Part 1 (the Accessories)

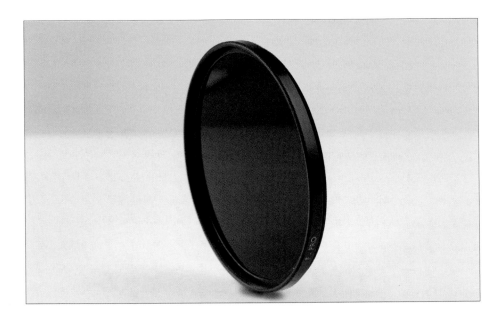

Although this is a four-part technique, don't let that scare you out of trying it—it's very simple to do. To make images like this, which are often taken during daylight, your camera's shutter has to stay open quite a long time, which would normally make your image a white, blown-out mess. So, what's the trick? You'll need a neutral density (ND) filter, which darkens the scene (by like 8 to 10 stops of light), so you can shoot long exposures like this in broad daylight (don't put it on your camera yet, though—you'll see why in a minute). Because your shutter will be open for literally minutes at a time, you're going to need to shoot on a tripod. But, you'll also need one other piece of gear: a cable release (a cord that attaches to your camera to fire the shutter button, so you don't move the camera by pressing the button with your finger. They make wireless shutter releases for many cameras—it just depends on your camera model).

Scott's Gear Finder

Hoya's 9-stop ND x400 ND filter for around $63–$120 (depending on size)

LEE Filters' Big Stopper 10-stop ND Glass Filter for around $160

B+W's 10-stop #110 ND filter for around $56–$228 (depending on size)

Long Exposure B&W, Part 2 (the Settings)

Now you'll need to set up your camera to take the long-exposure images. The first step is to set your camera to manual mode (don't worry—even if you've never shot in manual mode, you'll be able to do this). Next, set your shutter speed to a setting called "bulb" mode. When your shutter speed is set to bulb mode, your shutter will stay open as long as you hold down the button on your cable release (which you'll need to do to create these long exposures). In some cases, you'll be holding this button down for minutes at a time, but luckily, most cable releases these days come with a lock slider. So, once you press-and-hold the shutter button on the cable release, you can turn on the lock, so you don't have to worry about standing there holding the button down for a long time, or worry about your thumb slipping off the button and ending your exposure early. Also, because your shutter will be open for a while, you want to make sure you're shooting at the cleanest possible ISO (this will keep you from having too much noise appear in your image). On most Nikon DSLRs, that's 200 ISO, and on most Canon DSLRs, that's 100 ISO. Lastly, choose an f-stop that will put everything in focus (ideal for landscape shots like this). I generally shoot these at f/11. So, just to recap: we picked up an ND filter (but didn't put it on our lens yet), our camera is on a sturdy tripod, we attached a cable release to our camera (or we're using a wireless release), we've switched to manual mode and set the shutter speed to "bulb," we've set our camera to shoot at the cleanest possible ISO, and we set our f-stop to f/11. Okay, we're not done yet, but we're getting close.

Long Exposure B&W, Part 3, (the Setup)

The reason I had you wait to put your ND filter on your lens is this: it will make things so dark, your lens won't be able to see anything to focus on, so we set the focus before we put the filter on. Here's how: (1) First, aim your camera at the scene you want to shoot and compose your photo just the way you want it. Then, (2) press your shutter button halfway down to set your autofocus. Now, (3) on the barrel of your lens, switch your focus to Manual. That way, your focus won't get messed up once you put the filter on. With your focus set, go ahead and attach your ND filter to your lens. And, believe it or not, there's something else that could ruin your long exposure—light sneaking in through your viewfinder. Some DSLRs actually have a little switch that puts a cover over the viewfinder, but if your doesn't, but put a small piece of black gaffer's tape over it (we use gaffer's tape, because it comes off easily when you're done, without removing the finish from your camera, lens, or almost anything you'd want to stick it to).

Long Exposure B&W, Part 4 (the Shot)

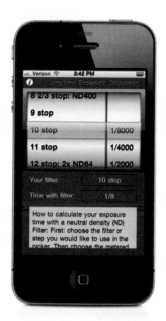

Everything's set and ready to go—it's time to take your shot. There's just one question kind of hanging out there: How long do you keep that shutter button held down to make a proper exposure? Well, of course, you could just experiment with different amounts of time, and after a few tries, you'll get it figured out, but there's a faster way: If you have an iPhone, go to the App Store and download the free LongTime Exposure Calculator app, which does all the math for you. You tell it which kind of filter you're using (8-stop, 10-stop, and so on), and it tells you how long to keep the shutter open. If you don't have an iPhone, you're not out of luck. Photographer Alex Wise created a free handy chart in PDF format, which you can download and print out (and keep in your camera bag), and it tells you how long to leave your shutter open for various ND filters (here's the short link to it: http://bit.ly/tKs1aj). Once you know how long to leave that shutter open, you're ready to shoot. So, press-and-hold the cable release button, lock it into place, and then just release the lock at the time you calculated using the app, the free PDF chart, or by just figuring it out using your watch. That's it. (*Note:* To see how I convert the image to black and white, check out the video I created for you. You can find it on the book's companion website.)

Keeping Your Gear Dry Outdoors

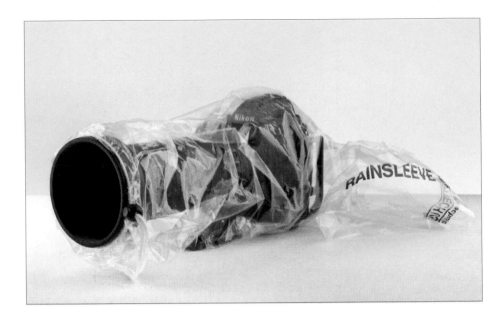

You can buy all sorts of sophisticated rain covers if you wind up shooting in rainy weather quite a bit (take a look at Think Tank Photo's Hydrophobia® covers, which are awesome, but expensive), but the problem is that if the weather unexpectedly turns bad, chances are you might not have a rain cover with you (if you have a small camera bag, it probably won't fit). That's why I keep a package of OP/TECH Rainsleeves in my camera bag at all times. They're not fancy, but they're small enough to always have with you in your camera bag (and they work with lenses up to 18" long). Plus, they're cheap as anything—you can get a pack of two for around $6. I've had to use them before, and they do a pretty decent job for those times you get caught by surprise.

Use Grid Lines to Get Straight Horizon Lines

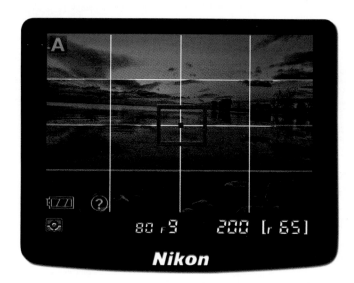

There's nothing worse than a crooked horizon line, and back in the first volume of this book series, I talked about using a double level that fits into your hot shoe mount on the top of your camera as one way to make sure your camera is level. If you don't feel like buying one of those, here's something that can help: Turn on your camera's Grid lines. Depending on your camera, these might already be on by default, but if not, when you turn them on, it adds horizontal and vertical lines to your viewfinder, which can be really handy in lining up your horizon line (I use this quite a bit—I just put one of the horizontal lines right along the horizon and I can see right in the viewfinder if my horizon line is straight). On Nikon DSLRs, to turn this feature on, go under the Custom Settings menu, under Shooting/Display, and choose Viewfinder Grid Display. Toggle the menu to On and click the OK button. (*Note:* This feature is not available on Nikon D3 series cameras.) On Canon DSLRs, go the Set-up 2 tab, under Live View/Movie Shooting Settings, and turn Grid Display On.

Instant Duotones for Landscape Images

If there's one place where duotone effects look great, it's on landscape images (they can work great for some portraits, too, but I always felt they were born for landscapes). They've always been kind of a pain to create, which is why I've felt photographers don't use them more often. But, I've got a technique for people who use Photoshop's Camera Raw or Lightroom that is so simple, you'll be creating great looking duotones in literally seconds. The first step is to convert the image to black and white. In Camera Raw (PS), go to the HSL/Grayscale panel and turn on the Convert to Grayscale checkbox. In Lightroom, in the Develop module, just press the letter V on your keyboard. Now, go to the Split Toning panel, but don't touch the Highlights sliders at all. Instead, go to the Shadows section and increase the Saturation amount to 25. Next, drag the Hue slider over to somewhere between 25 and 45 (that's usually where I stay for my own work, but you can choose any Hue setting you'd like—just drag the slider to choose a different hue) and you're done. That's it. Done. Finis. Really.

Amplifying Size in Your Landscape Images

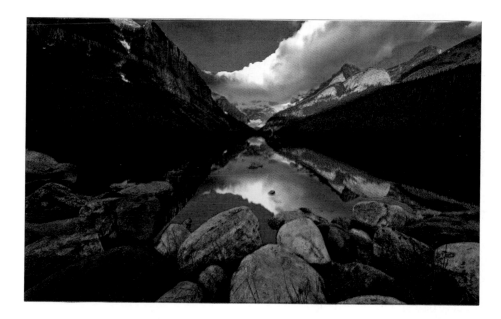

This is an old trick we use to give our landscape images a real sense of size and scope. It's going to sound amazingly easy, but it happens to work amazingly well. The trick is to first use a wide-angle lens, then position yourself so there's something right in your foreground (a rock or a series of rocks, a small tree, a flower, etc.), and then you get in nice and close to it. When you take the shot, it makes it look as though there's a lot of distance between that rock and objects in the background, and it gives your images this huge sense of scope, even though the rock and background objects may only be 100 feet apart. Try it the next time you're out, and you'll be surprised at the "bigness" this brings to your landscape images.

Need a Darker Sky? Lower the Brightness

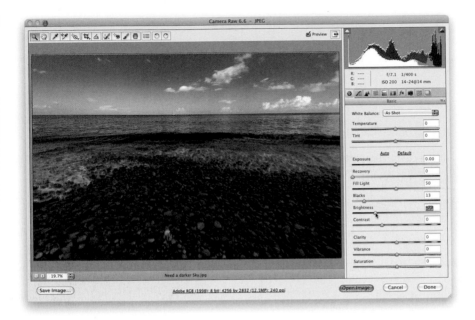

If I think the sky in a shot I've taken looks too light or too bright, I immediately know what to do—lower the Brightness. This essentially lowers the midtones, and it turns light blue skies into deep, rich blue skies fast. You can do this in Photoshop (or Photoshop Elements) with Camera Raw or in Lightroom's Develop module: just drag the Brightness slider to the left and watch the sky as you drag. If things get too dark, increase the Fill Light slider a bit until it looks right again. If you have to increase the Fill Light so much that the photo looks washed out, just increase the Blacks a little until it balances out. That'll do the trick! If you don't want to use Camera Raw or Lightroom to darken your skies (even though it's the easiest and most powerful way), you can lower your image's midtones by using Photoshop's Levels command (Command-L [PC: Ctrl-L]): just drag the center Input Levels slider (the gray triangle right below the center of the histogram in the Levels dialog) to the right. That'll darken the sky for ya. If everything else gets too dark, now it gets kinda tricky, which is why I recommend doing all this in Camera Raw (or Lightroom). By the way, you don't have to have shot in RAW to use Camera Raw—it edits TIFF and JPEG images, as well. From Adobe Bridge, click on the TIFF or JPEG image and press Command-R (PC: Ctrl-R) to open the image in Camera Raw. From the Elements Editor, choose Open (PC: Open As) from the File menu, click on the TIFF or JPEG, then choose Camera Raw from the Format (PC: Open As) pop-up menu, and click Open. Now, you can edit away. *Note:* If you're using the Lightroom 4 public beta (or, presumably, the "real" Lightroom 4 when it comes out), the Brightness slider is gone, so you'll have to use Exposure.

Shoot Before a Storm or Right After It

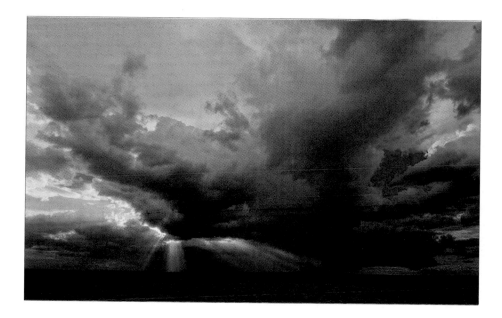

If you missed shooting your landscape photos around dawn or dusk (the two times of day when the absolute best light for shooting landscapes appears), you might still have an opportunity to create a really dramatic image if you see a storm rolling in or out of your area. That's because right before a storm, or right after one, you'll often find some really dramatic skies and enough cloud cover to create some really great light (rather than the harsh afternoon light we're usually saddled with). Interesting atmospheric stuff like this really looks great in photographs, so keep an eye out for these bonus shooting opportunities during the day (just play it very safe and avoid shooting in thunderstorms or anything dangerous. Remember, we're not on assignment for *National Geographic*. If we miss "the shot," it's not like we're going to miss getting the cover that issue. So, just play it safe at all times).

Doing Time-Lapse Photography

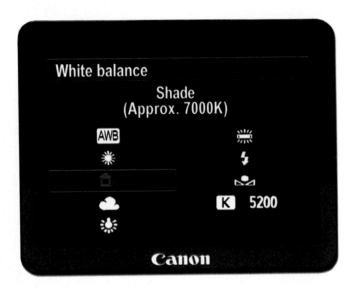

Time-lapse photography is great for showing things like a complete sunrise or sunset, or cloud movement across the sky, or stars moving across the night sky—basically, the progression of time throughout a landscape in a fraction of the time that has actually transpired (you shoot lots of still frames and then you turn those into a video). I explained how to set this up back in volume 3 of this book series, and even did a video on how to put all your shots together into a movie. But, here are two tips for when you're shooting time-lapse: (1) switch to manual mode (so your exposure doesn't change), and (2) don't use Auto White Balance (so it doesn't change, either).

Seek Out Still Water for Reflections

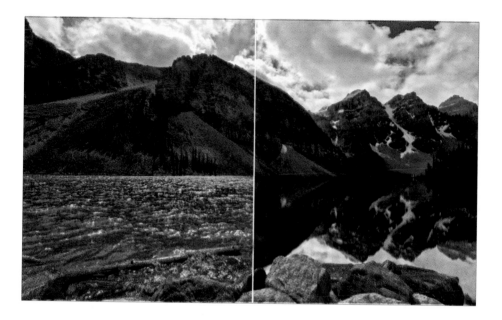

If you're shooting a charming little harbor, or a nearby lake, nothing looks lamer than choppy water. It almost doesn't even matter how amazing the surrounding scenery looks—if the water is choppy or has lots of little waves, it really hurts the overall image. That's why when we find a lake or harbor with still, glassy water, that alone almost makes the shot (thanks to the glassy reflections it creates). So, keep your eyes peeled for that glassy water while you're searching out your landscape shooting locations, and you'll already be halfway to creating a great shot. Now, your best bet for finding still water is first thing in the morning, right after sunrise, before the winds pick up. If there's going to be a time of day that you're most likely to have that glassy water, with gorgeous reflections, it's morning, so you need to set your alarm to get up really early. Not only will you have a better chance of getting still water, but you'll also be shooting in some of the best-quality light of the day—if you're shooting near dawn or in the half hour or so after dawn. Also, if you do get up early, make sure you bring along your travel tripod—in lower light, you'll need something to hold your camera steady, or you'll come back with a series of the blurriest, still-water shots in great light ever!

What to Do If the Tip Above Doesn't Work

If the water is choppy at dawn, then try the long-exposure trick at the beginning of this chapter, which will at least create silky water and look much better than choppy water. Plus, since you'll be shooting in lower light, getting a long exposure will be easier.

Tip for Shooting Those Low-Angle Landscapes

One of the big tricks for creating really impactful landscape shots is to shoot from a really, really low angle (you spread out your tripod legs, so your camera sits less than one foot from the ground) using a wide-angle lens—it gives your images a larger-than-life look. However, comfortably composing your landscape photos can really be a pain when you're down low like that (which is precisely why so few photographers are actually willing to do it, which is also precisely why your shots will stand out if you do). If you think you're going to be doing a lot of shooting like this, you can save your back (and keep your pants from getting wet and dirty during dawn shoots) by buying a DSLR camera that has a swing-out LCD screen. These are becoming very popular for shooting video with DSLRs, and they're ideal for shooting these low landscapes. Just switch your camera to live view shooting mode (so you see the live image on your LCD before you've taken the shot—kind of like you would with a point-and-shoot camera), then tip the swing-out screen up toward you, so you can clearly see what the camera is seeing and use that to help you compose the shot. You can even shoot with your LCD in that same position. Believe me—your pants and your back will thank me.

Make Your Cloudy White Balance Even Warmer

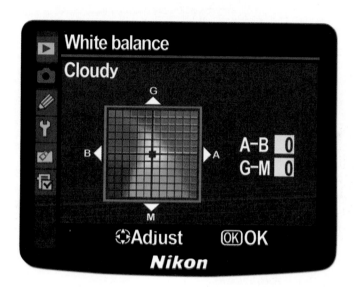

When I'm shooting landscapes, I generally set my camera's white balance to Cloudy to give my images a warmer look. However, if things start getting really overcast, the warm look I get from Cloudy almost disappears and my images look a bit cold again. So, I switch my white balance to Shade and that often does the trick, but sometimes the Shade preset looks too warm and yellow. In those cases, I just tweak my Cloudy white balance preset, so it's a little warmer. Luckily, this is really easy to do. On a Nikon, go to the Shooting menu, and choose White Balance. Scroll down to Cloudy and press the right arrow on the multi-selector. This brings up a color grid with your current white balance appearing as a dot in the center of the grid (shown above). To make your Cloudy preset warmer (Nikon calls this "fine tuning your white balance"), just use the multi-selector to move that little center dot over to the right toward A (amber; or diagonally down and to the right corner to add a little magenta in there, too). Now, press the OK button and you've created a warmer version of the Cloudy white balance. To return to the regular Cloudy preset, just choose it from the White Balance menu again. On a Canon, press the white balance selection button and then choose Cloudy. To make the Cloudy preset warmer (Canon calls this "White Balance Correction"), under the Shooting 2 tab, choose WB SHIFT/BKT, and then press the Set button. A color grid will appear on your LCD with your current white balance appearing as a dot in the center of the grid. Use the multi-controller on the back of your camera to move that little center dot over to the right a bit toward A (amber; or diagonally down and to the right corner to add a little magenta in there, too), then press the Set button.

The Landscape Image Post-Processing Secret

I had been looking at the work of a few of my favorite landscape photographers a few years back and all their images seemed to have a particularly vibrant look to them—one that I wasn't able to easily reproduce in Photoshop (and I like to think I'm pretty decent in Photoshop). I finally asked one of them about it, and I was pulled over to the side and told about this plug-in and, in particular, a specific filter in this plug-in and a filter preset that a lot of these photographers were using to get "that look." Of course, I've been using it ever since I learned about it, and it's one of today's landscape photographers' secret weapons for making really warm, yet totally vibrant-looking, images. The plug-in is Nik Software's Color Efex Pro and the filter within that plug-in is called Brilliance/Warmth. It does an amazing job—once you click on it, click on the little pages icon to its right, and then choose the 06–Warm Colors preset. You can also tweak it with the sliders on the right and save it as a new preset. Nik Software lets you download a 15-day free trial of the Color Efex Pro plug-in, so you should at the very least give it a try. (By the way, I don't get any kickbacks or commissions whether you buy the plug-in or not. I'm just telling you about it because I use it, a lot of landscape photographers use it, and I think you'll totally fall in love with it. Then it can be your "secret weapon.")

What Helped My Landscape Photos the Most

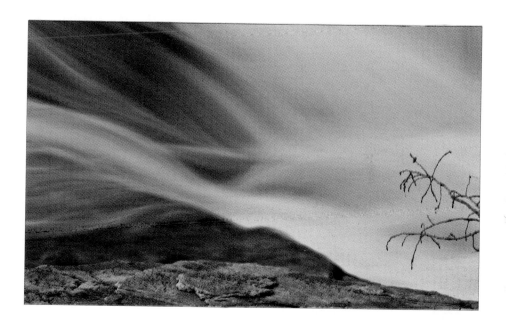

If I had to pick one single thing that helped my landscape photography improve the most, it was realizing that our job is to compose to remove distracting things from our images. One thing in particular to keep an eye out for is branches that extend into your image—either from the top, bottom, or sides of your frame. These are scene killers and you should go out of your way to avoid them when you're out shooting. Rocks make a nice foreground. Branches don't, so avoid them like the plague when you're composing your shots. When I teach landscape workshops, we do in-class critiques of students' shots from the week (we do them "blind" without mentioning the student's name), and the one thing we wind up pointing out the most are those little distracting things like power lines, plants, branches, and other little scene stealers. Often, all they would have to do is move one foot to the left or right, or point their camera two inches up or down, and it would eliminate the problem. But, you have to be aware of the problem in the first place to start avoiding that stuff. Take a look through your own landscape images and see if you can find distracting stuff in the background or along the edges of your image. Now, imagine how much better and cleaner they would look if that stuff weren't there. Your job is to compose to keep that stuff from being in your frame in the first place. When you become hyper-aware of that stuff and work to keep your background and edges clean and simple, I guarantee your work will move up a big notch.

Chapter Seven

Pro Tips for Shooting Travel Photos

How to Come Back with Images You're Really Proud Of

It doesn't matter what kind of photographer you classify yourself as (a wedding photographer, portrait photographer, landscape photographer, and so on), at some point, you're going to go on vacation, and because you're a photographer, you're going to take a camera, and because people know you're a photographer, they're going to expect you to come back with some amazing travel photos from your trip. This, of course, puts a tremendous amount of stress on you at a time when you took a vacation to relieve stress in the first place, so what you're really doing is trading one type of stress for another type of stress, and that is really stressful. So, I'm going to give you an absolutely can't-miss solution that will let you return from your vacation with some fantastic, iconic travel photos, no matter how short your stay in a particular city might be, and knowing you can pull this off in a minimum amount of time (30 minutes tops) will remove the stress and let you actually enjoy your vacation. Here's what you'll need to get started: a telephoto zoom lens, unobstructed access to your hotel room window, a chair, an inexpensive tripod, and about $10 cash per city. Start by going to a local gift shop and buying a set of postcards. Be picky here—don't just choose any set—choose a set that has the type of photos you'd like to call your own (don't worry, we're not going to hand these out and call them our own—they're obviously preprinted postcards). Take these back to your hotel, separate each card (they're usually perforated), and sit the first one on the chair, facing the window. Position your camera, on the tripod, with the soft light from the window at your back. Now, zoom in tight on the photo, so you don't see any white border around it (make it fill the frame) and take a photo of that postcard. Repeat this for the rest of the set, and then enjoy a day of stress-free vacationing, knowing that you nailed some shots for the folks back home. Hey, I never said this was the least bit ethical. I just said it would remove your stress.

Wait for the Actors to Walk Onto Your Stage

This is a wonderful travel photo technique and one I picked up from city life photographer Jay Maisel (I've tried it countless times now, and it works like a charm). When you find a really colorful wall in the city where you're shooting, walk across the street from it and just wait with your camera at the ready. A parade of people should pass by that wall in the next few minutes and, invariably, one or more of those people will have something colorful on that really stands out, or contrasts beautifully against that colorful wall, and you'll wind up with a captivating and colorful travel shot. If it's a rainy day, not only will your colors be nice and saturated, but there's a reasonable chance somebody will walk by with a red umbrella (against your yellow wall, or vice versa). All it takes is a little patience and some luck.

Leave Some Room for Your Subject to Walk

When you compose the shot we're talking about above (the one where you wait for someone to walk onto your set), make sure you compose that shot so there's a decent amount of room in front of the subject. That way they don't look "crowded" in the frame, which viewers find distracting in photos. They should have room to walk a few steps before they'd hit the edge of your image.

Look for That Classic "Lone Tree" Shot

When you head to the outskirts of a city, keep an eye out for a shot that's always a pleaser—the "lone tree" shot. It can be in a field, or a meadow, or on the top of a hill, but if you keep your eye out for one, more often than not, you'll find one, and they make for really interesting photographs. Of course, you might find a row of three or four trees, so in that case, just frame the photo so it looks like there's only one tree (crop the other trees out while you're framing the shot, and leave a lot of empty space to the left, or right, of the one tree that you leave in the frame, and it will have that "lone tree" effect). Two more quickies: (1) your lone tree doesn't have to have leaves on it (I saw exactly that on the cover of a digital photography magazine this month), and (2) if it's a foggy day, you get extra points for including that nice foggy atmospheric effect (try that one as a black and white. Could be really sweet!).

Cheating the "Lone Tree" Look

If you're on vacation and you really want the "lone tree" look, but you're not able to find it by driving around the countryside, I know a place you can look where there usually are one or two trees to choose from (but if you use this tip, don't tell anyone where you found the tree). Just drive by the local golf course in the city where you're traveling. You're pretty likely to find a long flat area of grass (maybe the 8th hole) and then a lone tree or two just waiting for you. Don't tell anyone I told you this one.

Camera Bags That Won't Attract the Wrong Kind of Attention

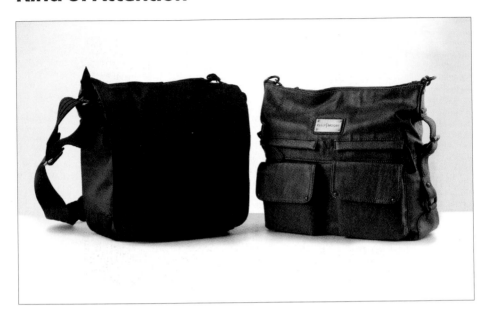

If you're traveling in some exotic locations (or even some places here in the U.S.), it's very possible that your camera rig costs more than the people passing by you on the street make in a year (if you have high-end gear, maybe two years). That's why you don't want to go around advertising, "Hey, I've got a camera bag here full of expensive equipment!" Believe me, thieves know what an expensive camera bag looks like, which is precisely why camera bags that don't look like camera bags are getting so popular (almost every big bag manufacturer makes at least one "in disguise" camera bag these days). For example, Think Tank Photo makes the Urban Disguise line of camera bags that don't look like camera bags. Kelly Moore (http://kellymoorebag.com) makes beautifully designed camera bags for women that look nothing like camera bags—you'd swear they were purses or totes. Lowepro makes one called the Exchange Messenger bag that looks...well...like a messenger bag. There are more out there, but the important thing is this: if you want to carry your gear safely and not raise the attention of thieves on the lookout for expensive camera gear, at least you've got some options.

Don't Draw Attention to Your Camera Make and Model Either

Savvy thieves know when they see a tourist carrying a camera like a D3 or a 1Ds Mark IV they've hit the jackpot, which is why you might consider putting a small piece of black tape over your brand and model. Also, don't use a camera strap that spells out the name of your gear, so it can be easily seen by anyone 10 feet away.

How to Avoid Blurry Travel Shots

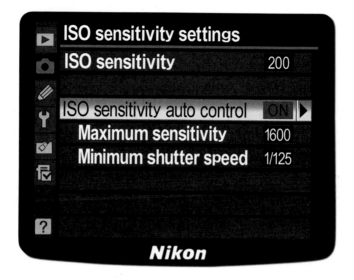

There are touching, hilarious, outrageous, beautiful, and totally unexpected things happening every day in the city you're visiting, and you don't want to miss one of those "moments." When you do capture one of those moments, there's a decent chance that the shot will wind up being blurry (it happens to travel photographers every day). If it's blurry, it's probably because your shutter speed fell below ⅟₆₀ of a second (unless that moment you caught happened directly out in the midday sun). That's why this tip (which I picked up from my buddy, Scott Diussa) is so important—it keeps you from "missing the shot" due to slow shutter speed by turning on your camera's Auto ISO feature. This tells your camera to automatically raise your ISO if it sees your shutter speed get too slow. In fact, when it's turned on, it won't let any of your shots get below a minimum shutter speed that you choose (I choose ⅟₁₂₅ of a second, because almost anybody can hand-hold a shot at that speed and it'll be in focus). To turn Auto ISO on, on a Nikon, go under the Shooting menu, under ISO Sensitivity Settings, go to ISO Sensitivity Auto Control, choose On, then choose ⅟₁₂₅ of a second as your Minimum Shutter Speed, and click OK (whew!). On a Canon, press-and-hold the ISO +/– button, then use the main dial until you see A (Auto) appear in the LCD on the top, then choose ⅟₁₂₅ as your minimum shutter speed. One last thing (for both Nikons and Canons) and that is "How high can you let the maximum ISO get?" Most DSLRs today can shoot at 800 ISO and it looks pretty decent, but I would still set your maximum at 1,600 ISO, because a photo with a little noise (which usually only other photographers will notice) beats the heck out of one that's even a little bit blurry (which everybody will notice).

My Favorite Travel Lenses

Back in volume 2 of this series, I mentioned that I like to keep my camera rig really light and simple when I'm on vacation, because after all, I'm on vacation (not on assignment). So, I usually go with just one lens that "does it all." With a cropped sensor camera like a Nikon D300S or a Canon 60D, I take my 18–200mm lens (both Nikon and Canon make an 18–200mm f/3.5–f/5.6 lens), so I can cover everything from wide-angle to tight zoom without ever changing lenses. For a full-frame camera, like a Nikon D700 or D3S, Nikon makes a 28–300mm f/3.5–5.6 (which is pretty close to the equivalent of the 18–200mm on a cropped sensor). This has become my "go-to" lens for travel, because once again, it covers it all (from wide-angle to tight zoom). For a Canon full-frame camera, like the 5D Mark II or 1D X, Tamron makes an affordable 28–300mm lens. If it's an important trip to somewhere really exotic, then you might want to consider taking a super-wide-angle (like a 12–24mm for cropped sensor bodies or a 14–24mm for full-frame bodies) for wide cityscapes or big sweeping scenes at a temple.

Don't Carry a Camera Bag—Carry a Lens Bag!

If you're only taking one extra lens (like I mentioned above), you might want to consider taking along a lens bag. They're smaller, they strap across your chest (much harder for anyone to swipe in big cities), and they're just big enough to hold a lens, a cleaning cloth, and a filter or two. Check out the ones from GoBoda. Really well-designed.

The Trick to Capturing Real Lives

©ISTOCKPHOTO/CHRIS PRICE

When you walk into a foreign city with a big camera and a long lens, you stick out like a sore thumb and draw lots of attention. At first. But the longer you hang around a particular area, the more people realize you're harmless, and after a while, nobody's really paying much attention to you. That's the goal. To get to the point that nobody's really paying much attention to you (the opposite of the rest of our lives, right?). When they're not focused on you and what you're doing, they go back about their business, and when that happens, some real opportunities to capture memorable photos appear. The trick really is to camp out somewhere and just be patient. You can sit down at a sidewalk cafe, or perch yourself on a short wall, or even sit down on some steps, or on the ground and lean against a wall—just pick an area that's near the middle of everything, but not directly in it. Remember, your job isn't to be in the middle of everything, it's to have a good view of the middle of everything. So, from across the street, or from above on a bridge, or on a staircase, or anywhere just outside the middle is where you want to be. You're just "chillin'." You're not making a fuss, you're not messing with your gear, and you're not drawing attention to yourself. Just give everybody some time to get comfortable with you being there, and then you can capture real life as it unfolds in front of you. I promise you—your patience will pay off.

Tourist Removal Shooting Techniques

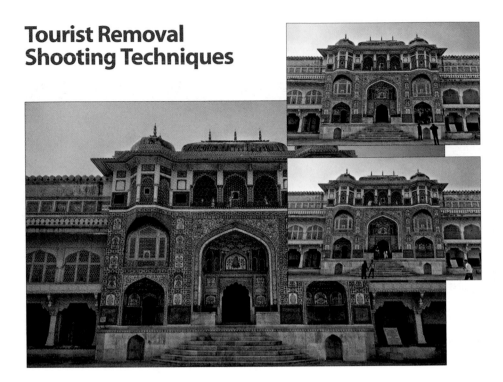

Tourists can make or break a scene. Sometimes, groups of people around a temple, church, or monument tell a story, but sometimes they just ruin what would otherwise be a really tranquil scene. That's why you need a strategy for "removing tourists" from your shot. First, I've found that patience alone can pay off big time in these situations, because if you just stand there and wait, you could luck out and, if only for a brief moment, have no tourists visible in the frame (that doesn't mean there are no tourists—it just means there aren't any in the particular spot you're aiming at). If that doesn't work, then your strategy changes to the "moving tourist" strategy, which is based on the fact that tourists don't stay in one place very long, and since that's the case, you're going to shoot a series of shots over a few minutes (not a few seconds—it usually takes at least three minutes). This trick works best if you're on a tripod, but you can hand-hold if you're the really patient type (don't leave the exact spot where you took the first shot). Once you're ready to shoot, take one shot, then wait until the main group of tourists has moved away from the area. Now, take another shot (I know, more tourists will be wandering around—that's okay, just take the shot). Wait a minute, and take another shot. This all takes place while tourists are wandering around what you're shooting. When you're done, you should have five or six shots of the exact same view. Now, go watch the video (on the book's companion website) to see how to use Photoshop or Photoshop Elements to make those tourists quickly and seamlessly disappear. You'll be amazed at how easy this is and how well it works.

Learn How to Work the Scene

If you're walking around a city or village and you stop to take a photo, that means something caught your eye (enough to make you stop and photograph it, right?). Don't just take one shot, shrug your shoulders, and move on. Remember, something made you stop, so there's probably something there, and taking one quick snapshot probably won't uncover it. Your job as a photographer is to "work that scene" and find out what it was that captured your attention. The first step is simply to slow down—stop, look around for a moment, and see what it was that drew your eye in the first place. Was it the color, was it a doorway, an archway, was it some little feature, or something big? If you can figure it out, then you'll know what to shoot, but more often than not, we can't exactly describe what it was that made us stop and shoot, but it definitely was something. Your job is to find it, and to work that scene by trying these techniques: (1) Shoot the area with different focal lengths—shoot a few shots in really wide angle, then try 100mm, then zoom in tight, and see what you find. Stop and look at your LCD to see if you're getting close. If you see something that looks like it has possibilities, then (2) try changing your viewpoint. Shoot it from a very low angle (get down on one knee) or try shooting it from above (look for stairs you can shoot from or a rooftop angle). This can make the shot come alive. If that looks really good and you're getting close to nailing the shot, then (3) try varying your white balance (try changing it to Cloudy and see if having the shot look warmer looks better, or try Shade for a warmer look yet). Try all these things (work the scene) and my guess is one of those shots will bring a big smile to your face.

Finding Which Travel Photos You Like Best

If you want to take better photos on your next vacation, start by looking at the photos from your last vacation. In particular, look at the metadata (the information embedded into your camera at the moment you took the shot, which includes which lens you used, your f-stop, shutter speed, ISO, and so on). But don't look at all the shots from your last trip, just the "keepers"—the ones that wound up in your photo album or slide show, or as prints on your wall. In that metadata, look for a pattern. Are a lot of those shots taken with the same lens? If they are, you now know which of your lenses is your "go-to" lens for travel photography. Now, dig a little deeper. Is there a particular focal length you're using (in other words, are you mostly zoomed in tight on these shots, like to 170mm or 200mm, or are they all mostly wide-angle shots, like 18mm or 24mm)? Once you pick up a pattern there (let's say most of your favorites were shot at 24mm), you know that for travel you seem to prefer wide-angle shots. So, to increase your chances of coming back with shots you really like, shoot more wide-angle shots with your go-to lens for travel. You can dig even deeper if you like. Are a lot of your favorites taken with a slow shutter speed, which shows motion, or are they mostly high shutter speeds where you're freezing motion? This helps you, once again, find your travel photography shooting style, and if you shoot more shots with that lens, focal length, and shutter speed you seem to like best, you're more likely to come away with more shots that you love.

Shooting from the Roof of Your Hotel

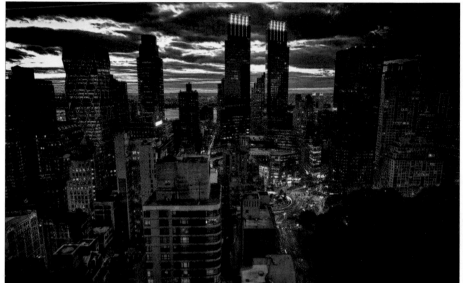

RAFAEL "RC" CONCEPCION

If you spot a high-rise hotel in the city you're visiting and you'd like to shoot a sweeping cityscape from their roof, it's pretty unlikely that they'll give you permission to shoot up there. Well, that is unless you're a guest in the hotel. I've found that if you're a paying guest in the hotel, and you contact the hotel concierge (or a friendly front desk staffer), you're fairly likely to get a few minutes to shoot on the roof (they will usually send you up there with a maintenance man or other hotel staffer). Also, if they have a rooftop lounge, and you want to shoot there in the off-hours when it's closed, they're usually more than happy to accommodate you—tripod and all. All you have to do is ask.

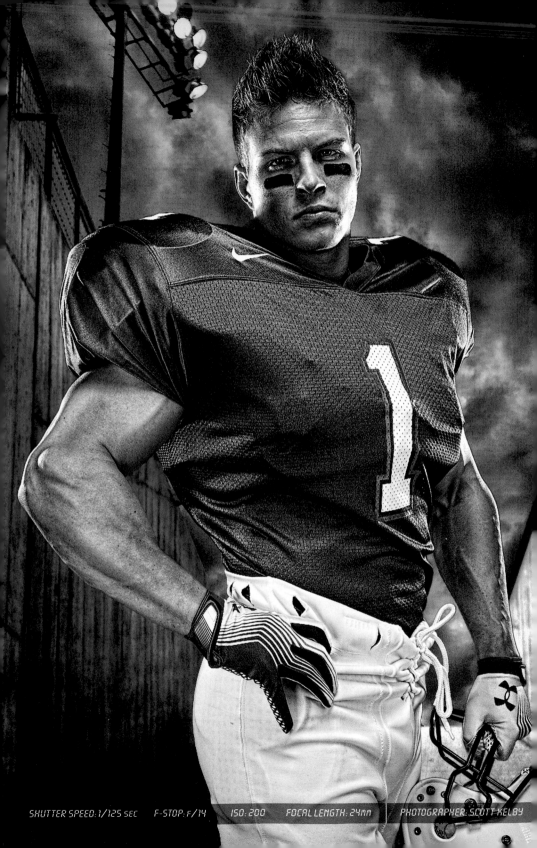

Chapter Eight

Shooting Sports Like a Pro

How to Get Professional Results from Your Next Sports Shoot

I know that these chapter intros are just here for a mental break, and they're not actually supposed to provide any useful information whatsoever, and I think I've done a fairly good job of living up to that lofty goal so far. However, I'm very passionate about shooting sports, and this is the only place I have to pass on a warning that is actually based in truth (or at least as based in truth as that movie *The Perfect Storm* was). Anyway, if you are a serious fan of college or pro sports, I want to tell you up front that you will rue the day you actually shoot on the field, because you will never, ever, ever, in a bazillion years even consider going back into the stands like a regular fan again. You will be literally ruined for life. Here's why: you get spoiled down on the field of play. It's a different game down there. It's not like what you see on television. You see, on TV, when you see a cornerback and a wide receiver jawboning back and forth before the snap, you figure they're trash talking. Talking smack. Occasionally, they are, but you know what they're mostly talking about? Nine times out of 10, they're talking about the gear the photographers on the sidelines are using. I was shooting an NFL game in Atlanta once, and I set up right near the line of scrimmage, and I heard the receiver say to the cornerback, "Dude, is he really trying to shoot this with a 200mm lens?" And the cornerback said, "I looked during the last time out—he's got a 1.4 tele-extender on there." Then, the WR said, "Did he have VR turned on?" The corner said, " Yup." Then, the WR said, "Dude, it's a day game. You know he's got to be at $\frac{1}{1600}$ of a second or higher" and just then the quarterback called an audible and yelled "Get me close to that guy with the 400mm f/2.8—I want to see if it's the new model with the nano coating." This goes on all game long, game after game, city after city. The players call it "camera smack" and just because you don't hear about it on TV, doesn't mean it's not happening.

A Tip and a Secret on Panning

If you want to show motion in a sports photo, the trick (which I covered in volume 1 of this book series) is to use a very slow shutter speed (like ⅟₆₀ of a second or slower), while shooting in continuous shooting (burst) mode, and then pan right along with the athlete so most, if not all, of the athlete will be in focus, but the background will be totally blurred (it really creates a sense of speed). I have another tip and a secret to add to that. First, the tip: when you're panning, swivel your hips as you pan (don't just twist at the waist), and you'll get much smoother results. So, while you're swiveling, shoot a burst of shots, in continuous shooting (burst) mode, so you get a string of shots as you pan. This will make a difference, but here's something you don't hear pros talk about very often: if you take a burst of 30 shots as you pan with an athlete (or a car, if you're shooting motorsports), only expect one of those to actually have your subject in focus. The thing to keep in mind is you only need that one! I've gotten so many emails from people just getting into sports photography, and they've written things like, "I've got all these blurry, out-of-focus shots and only one out of 20 is in focus" and I write back to them, "Then you're doing it just right!" Now, are there working pros out there that, in a panning string of 30 shots, have three or more photos in focus? Absolutely! But how many of those do they send in to their magazine editor, or wind up in their portfolio? One. So now you know, if you see a bunch of blurry panning shots, but you see that one in the bunch that's right on the money, you're gold, baby, gold!

Finding the Right Shutter Speed for Panning

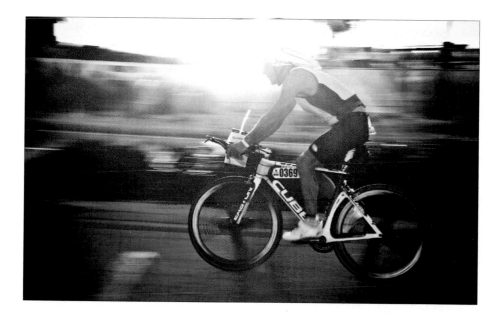

I have a lot of people ask me, "What's the right shutter speed for panning?" when shooting a subject like a runner, or cyclist, or racecar, etc. I hate to answer with a "that depends," but it kind of depends. I generally like to pan with my shutter speed at or below ⅟₃₀ of a second with a long lens (like 200mm or longer). However, if you use a wide-angle lens, ⅟₃₀ of a second won't be slow enough—you'll have to go much slower with your shutter speed when shooting with a 24mm, 18mm, or wider because of the lack of lens compression. You just won't see the motion like you do with a longer lens, so you'll have to back it way down to maybe ¼ of a second or less.

Freezing Motion Trick for Motorsports

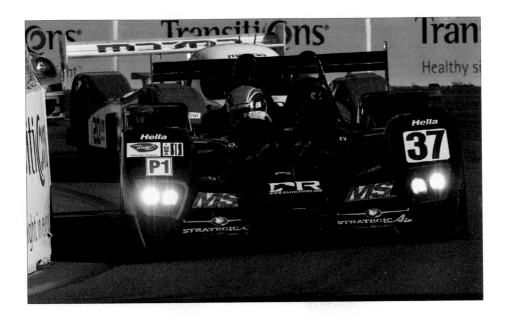

Back in volume 3 of this book series, I talked about shooting with a slow shutter speed for motorsports so you can see the wheels moving, which shows motion and speed (otherwise, if you freeze the motion, it looks like the car is sitting there parked on the track). However, there is one great situation where you can shoot at really high shutter speeds when shooting car racing (so you're pretty much guaranteed a super-sharp shot), and that is when you position yourself so the cars are coming almost straight at you. If you can't really see the sides of the wheels, you can't tell that they're not spinning (as shown above), so you can be sure you'll get lots of in-focus, super-sharp shots. Once you're in position, switch your camera to aperture priority mode, then shoot wide open at the lowest numbered f-stop your lens will allow (like f/4 or f/2.8), then (and this is key) focus your camera on the driver's helmet. If the helmet's sharp, the rest will be sharp. By the way, you don't actually need super-high shutter speeds to freeze the action if it's coming right at you—1/250 of a second will usually do the trick.

Shoot Slow-Shutter-Speed Panning Shots When the Yellow Flag Is Out

During a race, when the yellow flag is out, the cars are moving around the track much slower than usual, and this is a great time to capture some really nice panning shots at a slow shutter speed, simply because they're not moving fast. This makes your job of tracking the cars (and getting more in-focus shots while panning) much easier.

Your Problems Start at Night or Indoors

If you're shooting sports during the day, the world is your oyster, because you don't have to have lots of expensive equipment or crazy expensive lenses or any of that stuff. You can buy zoom lenses that go out to 300mm or 400mm for just a few hundred bucks from Nikon, Canon, Tamron, and Sigma (among others). For example, B&H Photo has a Canon 75–300mm f/4.0–5.6 Autofocus lens for less than $200. It's fairly small and weighs only a fraction of Canon's high-end 300mm f/2.8 lens, which costs around $7,300. (Yeouch!) But, since you're shooting in daylight, you can get away with it, and you'll get sharp, clean images (however, since you'll be shooting at f/5.6, you won't have as shallow a depth of field, so your backgrounds won't be as out of focus as with the $7,300 f/2.8 lens, but that $7,100 left in your pocket should help you get over that pretty quickly). So, when do you need to buy the really expensive camera body and heavy, crazy-expensive lenses? Only if you: (a) shoot primarily at night, (b) shoot indoor sports, or (c) you plan to shoot sports for a living. That's because, even in well-lit stadiums at night, to get to around the ¹⁄₁₀₀₀ of a second shutter speed you need to freeze the action, you'll have to shoot at f/2.8, and you'll still need to raise your ISO to at least 1600 (even shooting as low as f/4 in a well-lit NFL stadium, I have to shoot at 4000 ISO). Shooting at these higher ISOs without a camera body built for low-light shooting (like the high-end Nikon and Canon bodies— $5,000 and $7,000, respectively), the noise in your nighttime or indoor shots will pretty much destroy your images. So, shoot in the day, and you'll be able to afford to send your kids to college.

Turn Off VR (or IS) When Shooting Sports

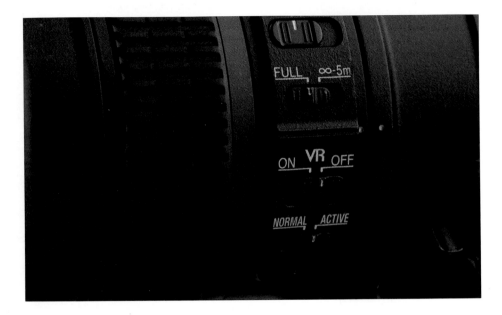

If you want sharper sports photos, and you have lenses that use VR (Vibration Reduction on Nikons) or IS (Image Stabilization on Canons), you should turn this off. There are two important reasons why: (1) the VR (or IS) slows down the speed of the autofocus, so it can stabilize the image, and (2) since you'll be shooting at fast shutter speeds (hopefully at 1/1000 of a second or higher), you don't get any benefit from VR (or IS), which is designed to help you in low-light, slow shutter speed situations. In fact, it works against you, because the VR (or IS) system is searching for vibration and that can cause slight movement. Normally, that wouldn't be a problem, because you want VR (or IS) to do its thing in low light, but in brighter light (and faster shutter speeds), this movement can make things less sharp than they could be, so make sure you turn VR (or IS) off.

The Advantage of Using Fast Memory Cards

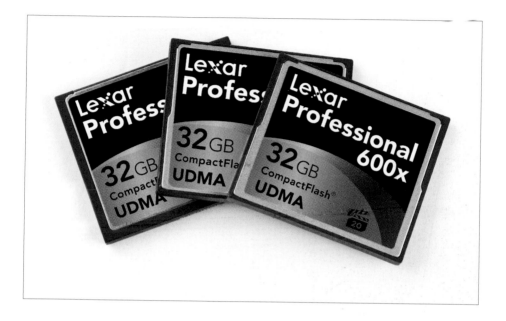

Fast memory cards were made for sports shooters, because we usually shoot in continuous shooting (burst) mode (capturing 8, 10, or 12 frames per second while we hold the shutter button down for seconds at a time). These bursts of images are temporarily stored in a memory buffer in our cameras and then they're written to the memory card in our cameras. If you use a "slow card" (like a 133x speed), then you're likely to experience the heartbreak of a full buffer at some really critical moment. What that means is you're firing off these rapid-fire shots (click, click, click, click, click, click), but then your camera's memory buffer gets full because those images in memory aren't writing to the memory card fast enough. Even though we still have our fingers tightly pressed down on the shutter button, and the player with the ball is running right at you, and you're about to get the "shot of the year," you all of a sudden hear "click.........click.........click........................click........................click" and your frames per second drops to about 1 frame every 2 seconds. Ugghhh!!!! This is why fast cards (like 400x and 600x speed) are a big advantage for sports photographers—faster cards write data much faster, so the images in your camera's buffer leave the buffer much quicker (leaving room for you to take more continuous shots), so your chance of hearing the dreaded "click.........click.........click" of a full buffer goes way down (and your chance of capturing that key moment stays way up).

How the Pros Focus for Sports

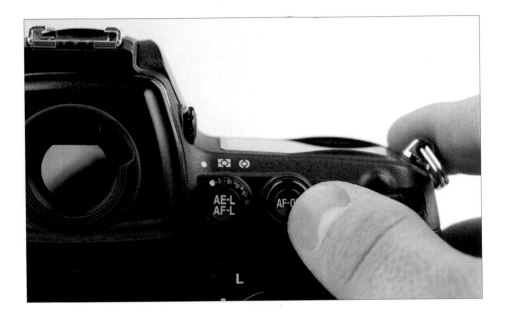

If you want to get more shots in focus, you've got to switch to back focusing (where you focus by pressing a button on the back of your camera body with your thumb, rather than focusing by pressing your shutter button). This makes a bigger difference than you'd think, because by separating the focus from the shutter button, your camera no longer focuses, then shoots—you've already focused on your subject with the button on the back, so now your shutter button just shoots. This back focusing helps to keep the autofocus from jumping off your subject when someone walks into your frame (which is a real struggle when shooting team sports), because if someone does walk into your frame (like a ref), you just take your thumb off the back focus button until they're gone (but keeping shooting) and when they're out of your frame, just hit the back focus button again. Generally, I just keep my thumb on that back focus button, aim at my subject, and then I don't have to worry about my focus—I just concentrate on my timing. To turn on this feature on Nikon DSLRs (well, most of 'em anyway), go to the Custom Setting menu and, under Autofocus, choose AF Activation, and set it to AF-ON Only. On Canon cameras (like the 7D or the 5D Mark II), press the Menu button on the back of the camera, go to your Custom Function IV-1 menu, and choose Metering start/Metering + AF start.

Why Many Pros Shoot Sports in JPEG

A lot of people are shocked when they hear that I shoot sports in JPEG format rather than RAW, but I'm not alone. Many of the pro shooters I know do the exact same thing for two key reasons (the first of which I covered in volume 1 of this book series): (1) You can shoot more continuous shots in JPEG format than in RAW, without filling your camera's internal memory buffer (see page 125 for more on the buffer issue). DPReview.com (a respected source for this type of data), broke it down this way:

Shooting in RAW: After about 17 RAW photos, your buffer is full.
Shooting in JPEG: You can shoot about 65 or so shots before your buffer is full.

If you're using fast memory cards (like 600x high-speed cards), that means that if you're shooting in JPEG, your buffer rarely gets full because of how fast the images write to the memory card, which clears up the buffer for more shots. (2) JPEGs take less time to process. JPEGs get contrast, color enhancements, and sharpening applied within the camera itself, so JPEG images look more "finished" right out of the camera and are nearly ready for publishing without a lot of tweaking. When you set your camera to shoot in RAW, it turns all those in-camera contrast, sharpening, and color enhancements off, because you've chosen to do all that yourself later in Camera Raw or Lightroom, which takes more time, as does resaving the images as JPEGs for publishing. You could shoot RAW+JPEG, but that has its disadvantages, including eating up memory cards much faster, and taking longer on import.

Using a Remote Camera

Having a second DSLR aimed at a different part of the field (or track, or arena, etc.) gives you a huge advantage, because you can cover twice the area and catch the shots and/or angles other photographers miss. For example, if you're shooting baseball from a dugout, and you want to cover the batter with your main camera, you can have a second camera aimed to cover second base. When you see a play happen at second base, you press a remote to fire your second camera. If it's mounted near you (or even on a tripod), you can just use a regular ol' cable release (or wireless cable release). If it's far away from you (like on the other side of the field, or down low on a horse track near the starting gate), you'll need two wireless transmitters (I use PocketWizard Plus IIs)—one connects to your remote camera with a small accessory cable, and you hold the other in your hand. When you see the action come into the view of your remote camera, you press-and-hold the remote button and it fires the shots (I always set my remote camera to shoot a burst of shots for as long as I hold the remote button down. I also pre-focus on the spot I want [like second base itself], then switch my focus to Manual, so it doesn't change when I press the remote button). Besides the wireless trigger, I would recommend: (1) a Manfrotto Super Clamp with a Manfrotto Variable Friction Magic Arm with Camera Bracket—this lets you mount the camera to all sorts of surfaces by just clamping it on, and then you can position it just how you like it. And, (2) you need to go to Home Depot or Lowe's and buy a safety cable or two to double secure your rig, so if something comes loose, your gear doesn't hit the floor, or worse yet, fall and hit somebody (a player, a fan, etc.).

Adding a Teleconverter to Get Really Tight

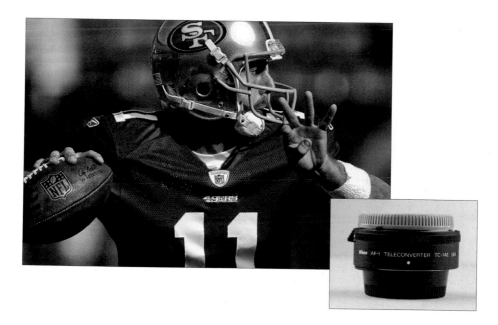

If you look at some of the really amazing sports shots out there today, many of them share something very specific in common—they bring you really, really close to the action. They bring you emotion and action that you'd miss from wide-angle TV shots, or from sitting up in the stands, or even from watching on the those giant stadium monitors. While I generally shoot a 400mm lens for almost every sport, I realized that I needed to get in even tighter—especially after having my portfolio reviewed by sports photography legend Dave Black, who encouraged me to put a 1.4x teleconverter in front of my 400mm lens (making it over 550mm in length) to get it even closer, and it made a tremendous difference. Whatever focal length you're shooting, a teleconverter is a fairly inexpensive way for you to get even closer to the action and take your sports shots up to the next level. (*Note:* This works best for shooting day games, or shooting in really well-lit situations, because putting on a 1.4x tele-extender makes you lose 1 full stop of light, so your f/2.8 lens becomes an f/4 lens, your f/4 becomes an f/5.6, and so on. If you use a 2x tele-extender, then you lose 2 stops. So, for daylight you'll be okay, but indoors, unless you have a camera body that shoots in low light with really low noise, it's kinda dicey, so keep that in mind.) By the way, Dave had a great quote for me about getting in close. He said, "Go big or go home!" He's right.

Why You Need to Shoot the Warm-Ups

The last thing you want to be doing at the start of the game is figuring out your settings and white balance. That's one of the two main reasons you need to show up early for whatever sporting event you're shooting and do this experimenting while the players are warming up. In almost every sport, about an hour before the event the players come out and go through pretty much whatever they're going to be doing when the game (or race) starts, and you want to be there shooting a lot during that warm-up. Not just so you get your settings down pat, and when the game starts all you have to worry about is capturing the moments, but also because, just like the athletes (or drivers) need to warm up before the start, you need to warm up, as well. If it's been a week or more since your last sports shoot, you need some time to shake the rust off and get back into the groove of panning with players, getting sharp on capturing the action, and just generally warming up. That way, when the game actually starts, you're not spending the first quarter (or period, or 20 laps) getting your settings and into the zone for shooting.

Shoot Little Details Surrounding the Event

A sporting event is more than the players on the field (that's why it's called an event). Today it's about the arena itself; it's about the fans; it's about all the sights and sounds that surround the event (if you shoot for a sports news service, they always ask for these types of shots to be submitted, as well). Since you're telling the story of the sporting event, it's about covering the details of the event. For example, when I'm shooting football, I always shoot a nice close-up of both teams' helmets (there's usually at least one sitting prominently on an equipment case in the bench area) or the football sitting there by itself just after the ref places it on the field for the next down. For baseball, I shoot a lone glove sitting on the bench, or some bats leaning against the wall in the dugout, or even a close-up of home plate. These storytelling shots are great to include in slide shows and always get a smile from the viewers, so make sure you keep these in mind to shoot between innings, quarters, periods, etc.

Getting More Football Shots In-Focus

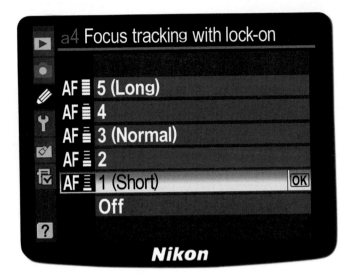

Although I use this tip primarily for football, this might help in a lot of different situations. There's a setting in many DSLRs that lets you choose how long your focus stays locked on your subject. By default, this Focus Lock-On is set to Normal, but for most of the football game, I leave it set to Short, so that way if I'm focused on the quarterback at the start of the play, but then he passes the ball, I can quickly swing over and catch the receiver and it refocuses on that player very quickly. However, there are times when I don't want my focus to leave the player quickly, and that's on kickoffs and punt returns. That's when I switch my Focus Lock-On to the Long setting. He's not going to pass the ball or hand off to anybody else (unless it's the final play of the game and they're behind one touchdown), so I need that focus to stay locked on him and not jump off him if another player (or a ref) crosses in front of him or nearby him (and of course, both teams are racing right alongside or in front of him, so there are players right nearby that might make your autofocus want to jump over to them). Just don't forget to switch it back to Short after the kickoff (or punt return). To change this setting on a Nikon, go under the Custom Setting menu, under Autofocus, and choose Focus Tracking with Lock-On, then choose Short during the regular game, and Long for kickoffs and punt returns. On Canon cameras (like the 7D), go to Custom Function III-1, which is AI Servo Tracking Sensitivity. Choose Fast for the regular game, and Slow for kickoffs and punt returns. *Note:* It's very possible that you'll run into a football photographer who does exactly the opposite of this, leaving his setting on Long the entire game. I personally haven't had a lot of luck with Long, but like everything else in photography, you'll find somebody that swears by it. So, which one is correct? Try 'em both and see (but again, I'm using the tip I shared here when I shoot).

SHUTTER SPEED: VARIES F-STOP: F/4.5 ISO: 200 FOCAL LENGTH: 14mm | PHOTOGRAPHER: SCOTT KELBY

Chapter Nine

Shooting HDR Like a Pro

How to Shoot and Process HDR Images

Anytime you mention HDR, it starts an argument, because there are both people who dearly love HDR and those who hate it with a passion that knows no bounds. Personally, I like HDR and I shoot them myself whenever I get a chance. However, I've found when I post HDR images online, I don't know what it is, but it brings out the worst in some people and they just have to post snarky comments like, "I'm sorry, but I hate HDR images" and other comments along those lines. After posting dozens of HDR images, I realized that people have an idea in their mind of what a "bad HDR" image looks like, and they apply that to any image a photographer notes is an HDR, so it's really not about the image any more— it's about the acronym HDR (which stands for High Dynamic Range). That's why I propose that we no longer use the acronym HDR and instead use the acronym "KMA" to describe our images. But, to appreciate this new acronym, we need to break it down to its basic form. Once you understand the nuances of the acronym, I think the entire HDR community will seriously consider adopting it. We'll start with the second letter, "M." When I post an image online, I'm posting one of "my" photos, so I think M is appropriate to represent the photographer that posted it. Then, I thought it would be cool to embed another popular acronym within our new acronym (kind of a Trojan horse acronym) and that would be the popular KISS (Keep it Simple, Stupid) acronym, which nearly everyone embraces, so we'll use "Kiss" as the first word. The third word in our acronym should be a short, ideally three-letter, word that describes people who write things like "I'm sorry, but I hate HDR images." So now, when someone writes something mean about an HDR you post online, you can respond by simply saying, "If you don't like HDR, you can KMA!"

Shooting HDR: The Gear

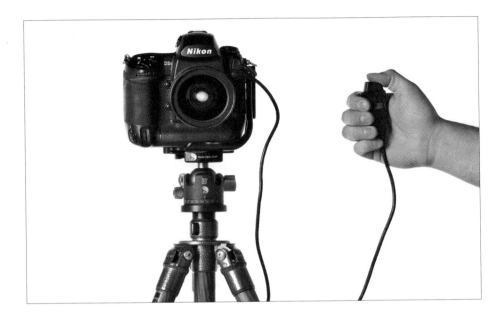

I was going to call this "The Essential Gear," but thanks to some pretty significant improvements in the software we use to create our HDR images, they're only essential if you're going to become a serious HDR shooter. You no longer absolutely need this gear to successfully shoot an HDR image, especially if you're just giving it a drive around the block to see if you like it. Now, if you try a few HDR shots, and you fall hopelessly and deeply in love with HDR (hey, this has happened to some of my friends—people who otherwise led normal, everyday lives until that point), then you should definitely invest in at least two pieces of gear that will give you better-quality HDR images. They are: (1) a decent tripod, unless you only plan on shooting HDR shots in really bright sunlight (which won't actually be the case, because some of the coolest HDR stuff is shot indoors), and (2) a cable release, so you don't wind up adding any extra vibration that might mess up your image. Now, there's a reasonable chance you already have both of these (especially if you've read any of the previous books in this series), and if you do, you should definitely be using both of these when you shoot your first HDR shot, because they will give you sharper images, and with HDR that sharpness is key. Also, since you might be considering just dipping your toe into the HDR pool of love, I want to let you know what the basic workflow will be, because it's a two-part process: the first part is shooting a particular way (hopefully using the gear just mentioned), because you know, up front, you want to create an HDR image, and the other part is combining these images into a single image and then adjusting that image so it looks good to you (more on all this on the following pages).

Shooting HDR: The Basic Idea

Before I get into specifics, I just want you to know two things: (1) shooting and toning HDR is actually fairly easy and probably way easier than you'd think, and (2) within the HDR community of photographers, no two seem to ever agree on anything, during any phase of this process, when it comes to making an HDR image. (Congress agrees more than HDR photographers do, as does the UN. Even lead singers and their bands agree more.) That being said, the first part of this process is shooting. You're going to set your camera up to shoot a series of shots of the same thing—without moving at all—and what you basically need is one regular shot, one shot that is underexposed (darker) by 2 stops of light, and one that is overexposed (brighter) by 2 stops of light—three images total of the exact same scene (some photographers shoot seven bracketed photos, or even 11, but for our purposes here, we're just going to use those three, which are enough to create a good-looking HDR image). If you use a Canon camera, and switch your camera to Av mode, set your f-stop to something like f/8 (see page 141), turn on Exposure Bracketing, and take three shots in a row, you'll have exactly what you need (one regular shot, one 2 stops darker, and one 2 stops brighter). That's the way Canon cameras and some Nikons (like the D7000) bracket—2 stops at a time. Some Nikons, however, only do 1 stop at a time, so you'll have to take five bracketed shots, even though you'll only use the first shot (normal), the second shot (2 stops darker), and the fifth shot (2 stops brighter). On the next page, we'll look at how to turn this bracketing on.

Setting Up Your Camera to Shoot Bracketing

First, I recommend setting your camera to aperture priority mode, so change your Mode dial to Av on a Canon DSLR or change your exposure mode to A on a Nikon. Okay, onto the bracketing: Exposure bracketing was actually designed to help us out in sticky lighting situations by taking more than one exposure of the same image. So, if you were off with your exposure by a stop or two (either you were too dark or too light), you could use one of those other images with the darker or lighter exposure—pretty clever when you think about it. Anyway, we use this feature to automatically take the exposures we need for HDR photos, because we actually need to combine a really dark photo, a regular photo, and a really bright photo into just one photo that will capture a larger range of light than our camera can capture in one single frame. Today, most DSLR cameras have built-in exposure bracketing, so all you have to do is turn it on. Of course, to make it extra fun for book authors, just about no two cameras turn this feature on in the same way. For Canon shooters (using a 50D, 60D, or a 7D), go to the second Shooting tab menu, and choose Exposure Compensation/AEB. Then, use the main dial on top of your camera to choose 2 stops in your LCD as the amount, and press the Set button. If you're a Nikon shooter, shooting a D4, D3, or D3S, there's a BKT button on the top left of your camera (shown above). Press-and-hold that button, then turn the main command dial on the back top right until it reads +1 in your LCD (this will take five shots. If you're using something like a Nikon D300, D300S, or D700, then just hold the (Fn) function button on the bottom left front of your camera (near the lens itself), and turn the main command dial on the back top right until it reads +5 (that chooses a five-shot exposure bracket). You are now set up to take your bracketed images for HDR.

A Canon Shooter's HDR Helper

COURTESY OF PROMOTE SYSTEMS

The nice thing about being a Canon shooter when it comes to HDR is that you can do exposure bracketing in 2-stop increments (where most Nikon shooters can only bracket in 1-stop increments, which means they have to take five shots to create an HDR image, where Canon shooters can take just three). However, what if you're a Canon shooter and you actually want to take a wider range of bracketed images, like five shots or nine shots? If that's the case, you'll want to get a Promote Control (from http://promotesystems.com), which lets you do those wider range brackets on Canon cameras, like the 7D, 50D, and 5D Mark II. The shackles have been lifted—overshoot away! (Just kidding.)

How Many Bracketed Shots Should You Take? Three? Five? Nine? More?

Like everything else in HDR-land, there are people who argue that three bracketed images are all you need, but some photographers swear by five, and there are others that always take nine images. Which number is right for you? Here's a way to know: shoot the same exact scene three times—once with three, once with five, and once with nine (Canon shooters can use the tip above). Then combine each set into an HDR image, tweak each one, and see if you can see a marked difference in the final image. Just remember, the more bracketed images you take, the longer the processing will take and the faster you'll fill your memory cards. I'm just sayin'.

What If Your Camera Doesn't Have Bracketing?

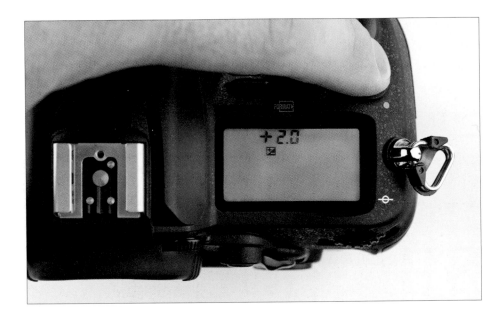

Don't worry, even if your camera doesn't have built-in bracketing, you can still shoot bracketed frames to create your HDR image—you just need to know the trick. Of course, start by setting your camera to aperture priority mode (A on Nikons, or Av on Canons), then choose your f-stop for your HDR shots (I usually shoot at f/11). Now, take one shot, then use the exposure compensation control for your camera to take the next shot at –2 EV (that gives you the 2-stops-darker shot you need), then go the opposite direction to +2 EV and take your third shot (that gives you the 2-stops-brighter shot that you need). That's it—you've got all three images you need to make your HDR shot. Now, if you haven't used exposure compensation before, here's how to turn it on: On Nikon cameras, hold the exposure compensation (+/–) button on the top of your camera, and then move the main command dial on the back to the right until it reads –2.0 on the LCD on the top. Then do the same thing for your next photo, but change it to read +2.0. On Canon DSLRs, turn the power switch to the second On position, then use the quick control dial on the back of your camera to lower the exposure to –2.0 EV, and take a shot. Then, do the same thing for your next photo, but change it to +2.0 EV.

Which F-Stop to Use for HDR

Another thing photographers don't agree on is exactly which f-stop to use, but everybody pretty much agrees you need to use an f-stop that keeps a lot of your image in focus. Personally, I generally shoot my HDR shots at f/11 and most of the pros I know use f/8, but if you go on the web and search for this, you'll find people touting everything from f/1.8 to f/32. So, who is right? That's easy. Me! (Kidding. Totally a joke.) People make great cases for all different f-stops for the particular subject they're shooting, but if you're new to this, why not try f/11 for starters? If you're shooting indoors, though, try f/8 as f/11 may over-expose your images.

Understanding What "Post-Processing" Means

In this chapter, you'll see the phrase "post-processing," and that basically means any-thing you do to the photo using software after the fact (like editing it in Photoshop, or in an HDR application, like Photomatix Pro, or any image editing program).

Don't Shoot One Bracketed Shot at a Time

If you're going to shoot a series of bracketed HDR shots (like three or five bracketed frames), don't shoot them one at a time. Instead, switch your camera to automatically shoot a burst of all three (or all five) when you press-and-hold the shutter button down just once. Here's how: On Nikon DSLRs, you choose burst mode (called "Continuous High Speed") by going to the release mode dial on the top left of your camera and switching to CH mode. On Canon cameras, you press the AF·Drive button on the top right side of your camera, then rotate the quick control dial on the back until you see a little symbol that looks like a stack of photos next to an H on your LCD (this is called "High-Speed Continuous Shooting"). Now, once you've turned bracketing on, you just press-and-hold the shutter button until you hear that all three (or five, or more) bracketed shots have been taken. Besides just being plain easier to do it this way, you'll get less camera vibration and the shots will fire faster in burst mode than they would having to manually press the shutter button three or five times in a row. Plus, using this method, you won't forget how many frames you've taken and won't have to ask yourself, "Did I just shoot four or five?" (Hey, it happens.) Now, if you're shooting HDR at twilight/night, oftentimes the exposures are going to get longer. By using a cable release (with your camera on a tripod), you can take advantage of its lock switch (just press the cable release button and lock it into place). While it's easy to press-and-hold the shutter button for three or five shots during the day, you may introduce shake for the night shots.

Shooting Hand-Held HDR Shots

I mentioned at the beginning of this chapter that you don't have to shoot your HDR shots on a tripod thanks to some advances in the HDR software that actually align your images and remove any "ghosting" that might happen from movement (and both work amazingly well). Now, whether you can get away with hand-holding really comes down to just one thing: how much light there is where you're shooting. If you're shooting outside in the day, it's probably not going to be a problem, so just hold your camera steady and fire away. If you're indoors, or it's stormy out, or if it's night, then it gets tricky. Now, I've hand-held five bracketed HDR shots inside a church, and they all came out pretty sharp. However, since I knew the light was low, I did two things that helped a lot: (1) I leaned on a column in the church to help steady me and my camera—this makes a bigger difference than you'd think. (2) I broke one of the big rules of HDR, which is to also shoot at the lowest ISO possible, because in the low light of the church, the lowest possible ISO for me to hand-hold was 800 ISO. So, the shot does look a bit noisy (grainy), but at least it's sharp. I would say at this point, I probably shoot more hand-held HDR shots than I do on a tripod. But, if I have a tripod handy, then I usually put my camera on it and use a cable release (the problem is my tripod isn't always handy). So, in short, don't let the fact that you don't have a tripod keep you from shooting bracketed HDR shots—just do your best (and use tricks like leaning against solid objects) to keep yourself still through three or five frames. Then let the software do the rest (aligning and removing ghosting).

Which Types of Scenes Make Good HDR Shots

Since the process of shooting HDRs is pretty mechanical (the camera does most of the work), the real creativity of HDR photography is finding shots that look great as HDR images, because not everything makes a great HDR image. In fact, some types of images just look fantastic as HDR, while others, like photos of people, well…in short, I'd just avoid shooting HDR shots of people. So, what does look good? Start by looking for scenes that have a wide range of light—really dark areas and other parts that are really bright. HDR was made for situations like this (which is why you see a lot of dawn and dusk landscape shots in HDR). So, extreme changes in light will give you the expanded range part, but you'll still need subjects that make for great HDR images. Scenes with lots of texture (like metal, wood, old paint, fabric, concrete, aluminum, and so on) really look great for this, which is why you see so many great HDR shots of old buildings, factories, old restaurants, airplanes, classic cars, old motels from the 1950s, and anything run down. Also, sometimes really modern things make great HDR too, like buildings with wild architecture, airports, etc. Finding these things is really an art, and it's a lot of the fun of creating HDR images. If you want to see what kind of cool scenes are popular for HDR, visit a site called http://500px.com (go to the Popular Photos link). You will see some amazing images, including lots of HDR photography that will inspire you to search for places you've probably driven by a hundred times and never thought anything about (except maybe, "When are they going to tear down that old building?"). Now you'll be wrangling to find a way to get inside to shoot it!

Shooting HDR Panos

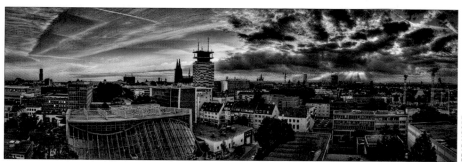

BRAD MOORE

Okay, this isn't hard to pull off (you absolutely can), but you've really got to want to do it, because it takes some time—both in the shooting phase and the post-processing phase. Here's why: First, you're shooting a pano, which means you're probably going to be shooting anywhere between eight and 12 images already, right? But, if you want it to be an HDR pano, you'll then have to shoot bracketed for three to five frames each (minimum) of those eight to 12 images. So, for example, if you shoot a Nikon D3S and your pano is going to be eight frames wide (moving from left to right), each of those eight frames will be bracketed at five frames each, so this one HDR pano will be comprised of 40 photos! (I told you this would take a while.) Anyway, here's how it's done: Step One: When you're ready to take the first frame, turn your exposure bracketing on (see page 138). Take the shot, but remember to press-and-hold the shutter button until it takes all five frames (or three; see page 137). Now, move to your second frame and repeat the process, shooting multiple bracketed photos each time you rotate your camera over a bit for the next frame, until you're done. Step Two: Process each frame individually (take the first three or five images and combine them into one HDR image, and so on). Once all your images have been combined, you should be back down to just eight frames that are all HDR single images. Now, open just those eight HDR images in Photoshop. Go under the File menu, under Automate, choose Photomerge, and ask it to use the images already open in Photoshop. Click OK to merge those HDR images into one wide panoramic image. Crop it down to size and add any additional post-processing to finish it off (see page 151).

Easily Find the Images You Bracketed for HDR

I hear from people all the time who shoot HDR images that they forget that they shot them because, in the hundreds of images they import into their computer (using anything from Bridge to Lightroom to iPhoto to Photo Mechanic), they can't instantly tell if their exposure was off a bit or if it's an HDR shot. This is particularly bad if you don't get a chance to look at your images the same day you shoot them, because there's a good chance you'll miss some here and there. That's why this tip, which I actually started using first when shooting panos, is so handy for making it easy to find your HDR-bracketed images When you're about to shoot your HDR image, before you turn on bracketing, hold one finger up in front of your lens and take a shot. Then, turn on bracketing, shoot your HDR-bracketed images, and then turn off bracketing. Now, hold two fingers up in front of your lens and take another shot. That way, when you're looking through the hundreds of shots you imported from your memory card, when you see a shot with you holding up your finger, that means, "Here comes an HDR." Now, if you shoot panos and HDRs, then put up three fingers to start your HDR and four when you're done. This is much handier than you'd think.

HDR Shots Generally Look Best If You Start with RAW Images

The more data your HDR image has, the better, so if you shoot in RAW, you'll get somewhat better results with your HDRs than you would shooting in JPEG. If you shot in JPEG already, no biggie, but if you get serious about HDR, you should probably start shooting at least those shots in RAW.

The Programs We Use for Creating HDR

Once you've taken your exposure-bracketed shots, you need a piece of software to combine these separate images into one single HDR image. Although there are a number of HDR programs out there, everybody seems to use the same three: (1) Photomatix Pro (shown above; http://hdrsoft.com), which is made by a French company (but the program is in English) and is the most popular HDR application out there. Its advantages are that it definitely has its own signature look, and it creates your HDR image quicker than any other HDR application I've tried. (2) Photoshop CS5's (or higher) HDR Pro (www.adobe.com/photoshop). In Photoshop CS5, Adobe overhauled their HDR capabilities and now it does a pretty decent job—especially on hand-held HDRs or photos with ghosting. The presets it comes with are very, very lame, but see page 148 for help with that. The advantages are, if you already have Photoshop CS5 or higher, you already own a program that creates HDR images. And, finally, (3) Nik Software's HDR Efex Pro (www.niksoftware.com). This one is fairly new, but photographers have really flocked to it. Its advantages are that is has a great, easy-to-use interface, lots of presets, and features like built-in vignetting and the ability to tweak individual parts of your images. It wins the feature war for sure. So, which one is the right one for you? You can download demo versions of each of them for free (including Photoshop), so try them out and see for yourself. Try each on the same HDR image, so you can compare the results side by side. Since they all work a little differently and all three have their own look, you'll quickly find out which one is the one for you.

A Good Preset for Photoshop's HDR Pro

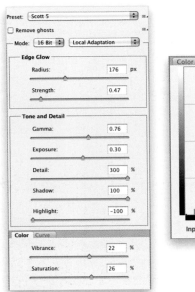

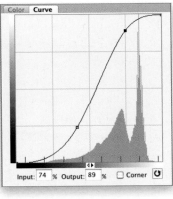

If you need to combine your bracketed images into a single HDR image, but you don't have either Photomatix Pro or Nik Software's HDR Efex Pro, but you have Photoshop CS5 (or higher), then you can use Photoshop's built-in HDR Pro feature (found under the File menu, under Automate) to combine the images and add the tone mapping. (*Warning:* If you have an earlier version of Photoshop [like CS4, CS3, or earlier], don't use the HDR feature at all. It's…it's…well…awful [sorry Adobe].) Back when CS5 first came out, the presets for tone mapping that came with HDR Pro were so lame that they were basically unusable, so I created one of my own that actually works pretty well for most images. I call it "Scott 5" (I know, it's a very creative name, but is it possible that I stole the name from the band Maroon 5? No, that would be too creative). Anyway, I'm going to share my settings with you here, so you can give it a try. You can see the settings above, but just in case, they are (from top to bottom): under Edge Glow, Radius: 176 px, and Strength: 0.47; under Tone and Detail, Gamma 0.76, Exposure 0.30, Detail: 300%, Shadow: 100%, and Highlight: –100%; under Color, Vibrance: 22%, and Saturation 26%. Lastly, I click on the Curve tab and add an S-curve like the one you see above on the right. This just adds an extra bit of contrast. You add points to the curve by clicking on the diagonal line, then dragging up or down. If you make a mistake, just click on a point and then press Delete (PC: Backspace). Now, once you enter these settings, you can save them as your own "Scott 5" preset by clicking on the icon to the right of the Preset pop-up menu up top and choosing Save Preset. That's it—you're all set.

Sharpening HDR Photos

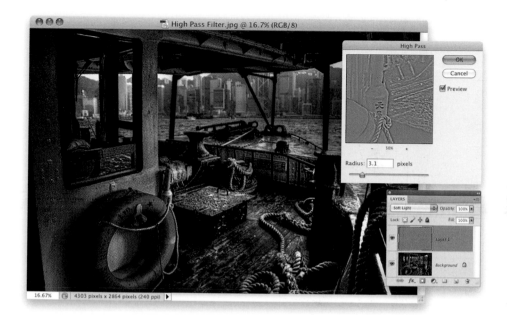

HDR pros get pretty aggressive when it comes to sharpening their images, because one of the hallmarks of a good HDR image is the overall sharpness. That's why a lot of HDR pros use High Pass sharpening in Photoshop, which is just another form of sharpening, but the type of sharpening it applies is really punchy, and it's easy to adjust right after you've applied it to your image. Here's how to apply High Pass sharpening: Step One: In Photoshop, duplicate your Background layer. Step Two: Go under the Filter menu, under Other, and choose High Pass. Step Three: Drag the Radius slider all the way to the left, until the screen turns solid gray, then drag it back to the right until you see a decent amount of detail appear, but not so much that you start to see halos around the edges of everything. Step Four: At the top of the Layers panel, change the blend mode from Normal to Hard Light (for extreme sharpening) or for a little more subtle sharpening (and the one I prefer to use myself), choose Soft Light. If that still seems like too much sharpening, just lower the Opacity of this High Pass layer until it looks right to you. That's it.

Shooting HDR Shots at Night

Although we think of HDR for balancing extreme lighting situations, HDR images at night of cities, buildings, and cafes can be really fantastic. Here's the tip: when you shoot scenes like these, change your f-stop to f/16, and the lights at night will have beautiful star brights.

The HDR Look Without Shooting HDR

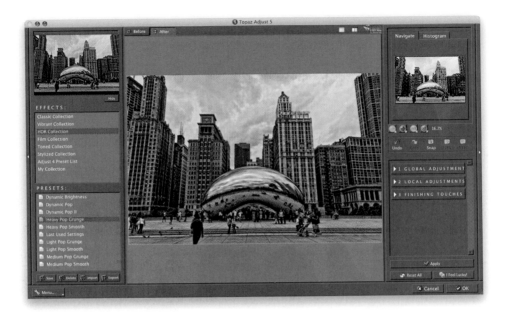

If you want a very HDR "look" to your images, but without actually shooting multiple images, download a Photoshop plug-in called Topaz Adjust (www.topazlabs.com) for around $50. Now you're just one click away from that look, because the plug-in has a bunch of built-in presets. For example, try Detail, or perhaps Clarity, or even Portrait Drama (found under the Vibrant Collection effects), which all have different HDR-type looks. If you really like that "Harry Potter surreal look" (as we like to call it), then try either Psychedelic or HDR Sketch, under the Stylized Collection effects (oddly enough, Psychedelic looks less psychedelic than HDR Sketch). Here, I chose the Heavy Pop Grunge preset found under the HDR Collection effects. So, if this plug-in does the trick, why shoot the three- or five-image regular HDR shots at all? Well, the plug-in doesn't capture any additional range of light, so it doesn't expand the range of what your camera captured—it just mimics the tone-mapping (the special effect part) of HDR photos. So, you really don't have an HDR photo—just one that most folks would assume is an HDR, especially at first glance.

Topaz Adjust Isn't Just for "Faking" HDR

A lot of the popular HDR pros out there actually use Topaz Adjust as part of their regular real HDR post-processing. They shoot in HDR, combine the images into a single image, then in Photoshop they use the effects of Topaz Adjust to tweak their images and give them a particular look. So, getting the Topaz Adjust plug-in isn't a bad idea, whether you want to apply it to single images or to multi-image real HDR shots.

What They're Not Telling You About HDR

If you've done any research on shooting and processing HDR images, you probably know that you have to shoot bracketed photos, and then you need some program to combine those bracketed photos into one single image (like Photomatix Pro, or Photoshop's built-in HDR Pro, or whatever). But, a lot of folks are disappointed once they've combined their bracketed frames into one HDR image, because they say, "My shots really don't look like the ones I see on the web and in books. What am I doing wrong?" It's not that they're doing something wrong, it's just that there's something the pros do that few are willing to talk about. They take their compiled HDR images into Photoshop and do quite a lot of post-processing there, tweaking everything from the color to the sharpness, adding Clarity, and even running plug-ins like Nik Software's Color Efex Pro (in particular their Tonal Contrast and Glamour Glow presets, which are very popular for finishing off HDR images). They probably spend more time in Photoshop than they do in the HDR software itself. So, if you're wondering why your images don't look like theirs, it's because they're doing one more big step to finish off their photos. Just so you know.

Photoshop for HDR

We produced a book written by my buddy (and co-worker) RC Concepcion called (wait for it…wait for it…) *The HDR Book: Unlocking the Pros' Hottest Post-Processing Techniques*, and it focuses on exactly how to post-process your HDR images in Photoshop. The book is a huge hit, and you can pick it up wherever really cool books are sold. You'll love it.

Fixing Halos & Other HDR Problems

If you create an HDR image and see halos around parts of the image that look bad, or you have an area with some ghosting that wasn't fully removed by your HDR software, here's a trick to deal with these problem areas: Open your HDR image in Photoshop, then re-open the normal exposure image from your bracketed shots (before you converted it to HDR) in Photoshop's Camera Raw. We want to give it a little "HDR feel" before we use it, so increase the Clarity and Contrast quite a bit (use your judgment to get it looking nice and crisp), then click Open. Now, press-and-hold the Shift key and drag that normal image right over on top of your HDR image (holding the Shift key aligns this image perfectly with the HDR shot below it). Option-click (PC: Alt-click) on the Add Layer Mask icon at the bottom of the Layers panel to put a black layer mask over your normal image, and hide it from view. Get the Brush tool and choose a small, soft-edged brush, set white as your Foreground color, and paint directly over the problem areas (with halos or ghosting), and it paints back in the normal pho-to in just those areas (which is why you want to use a pretty small brush—this is supposed to be a subtle touch-up). This can really work wonders, because the problems only came about once you combined the images into an HDR, so that original shot is pretty clean. If, when you paint, the original areas look too obvious, try lowering the Brush's Opacity amount to 50% (up in the Options Bar) and try again. If you need to erase something, switch your Foreground color to black and paint it away. By the way, if you drag the original image on top and it doesn't precisely line up with the HDR shot (which is likely), then select both layers in the Layers panel, go under the Edit menu, choose Auto-Align Layers, and click OK in the dialog to use the Auto mode (you might have to re-crop a tiny bit after it does its alignment thing).

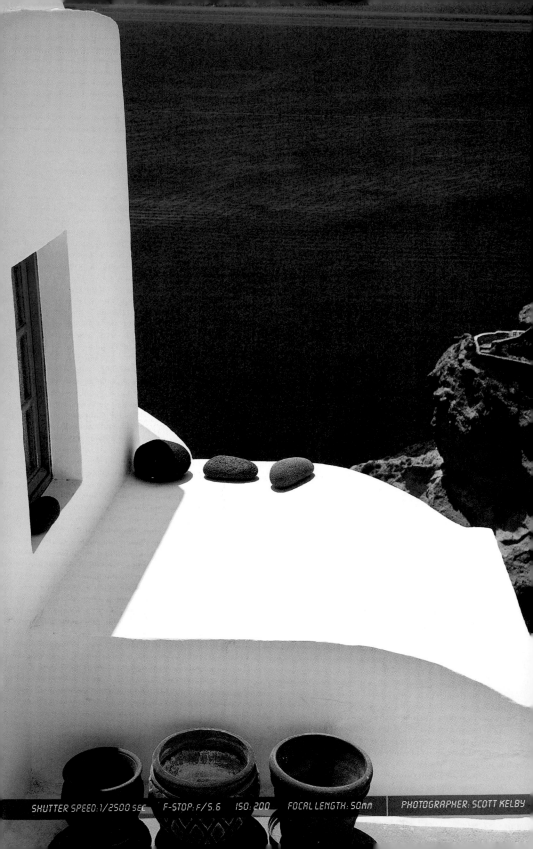

SHUTTER SPEED: 1/2500 SEC F-STOP: F/5.6 ISO: 200 FOCAL LENGTH: 50mm PHOTOGRAPHER: SCOTT KELBY

Chapter Ten

Pro Tips for Shooting DSLR Video

How to Get the Most Out of Your Built-In Video Capabilities

This is the first book in this series that has a chapter dedicated to shooting DSLR video, and when you think about it, it makes sense because you can hardly find a DSLR these days that doesn't have built-in HD video capabilities, so I thought it was time. But before you dive into becoming a DSLR filmmaker, there is a sad truth about the video industry that you'll need to come to grips with first, and that is: video accessories aren't like photographic accessories. They are insanely expensive. I think it's because, for years, anything to do with shooting or editing video had been so incredibly expensive (only big corporations with huge budgets could afford to create their own videos), and even though every DSLR now has video, the video industry really wants to embrace these photographers so they feel like real video producers. Of course, the only way to really experience the pain and suffering real video producers go through is to let them purchase a piece of video gear. Any piece of gear. It's a real shock to photographers, but if you don't believe me, try this: go to an online photo store and find a common accessory, like a polarizing filter, and write down its price (let's say it's $29). Now, go to an online video camera store and search for a similar polarizing filter for video cameras. The price will be around $300. This is why selling video equipment has been traditionally more profitable than running a Las Vegas casino. It's not just polarizers, though, because video production people have become accustomed to paying insane amounts for just about anything. For example, a box of paper clips, if purchased from a video accessories store, can run as much as $60. Maybe more. And forget about ordering things like a tube of toothpaste or some frozen waffles—they will require you to complete a credit application in advance. So, my advice to you is: never actually shoot video with your DSLR unless you are a rich doctor, lawyer, or you own a video accessories store.

You're Gonna Want an Eyepiece

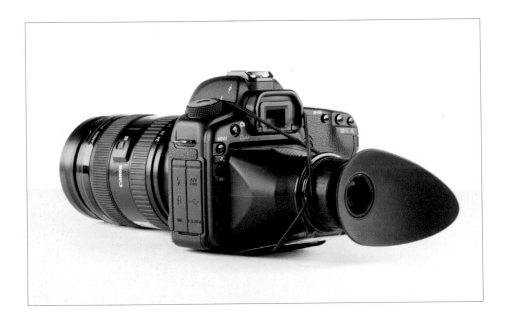

If you're going to be using your DSLR as a video camera for any length of time at all, you're really going to want an eyepiece (something that covers the LCD monitor, so you can hold it up to your eye like you would a regular video camera). Not only is it more comfortable and easier to see when you're out in daylight, but by resting the eyepiece against your face, it helps steady your camera big-time by adding another point of contact to your body. You can spend a bundle on an eyepiece, but the one I like is pretty affordable (well, for a video accessory anyway, and if you think photo gear is expensive, video gear is for oil barons), because it starts by using a Hoodman HoodLoupe (I talked about these back in volume 2 of this book series, and basically it's a hood you hold over your LCD monitor so you can see it clearly, even in bright sunlight, that runs around $80). Then, you pick up their Cinema Strap accessory (around $20), which easily holds that loupe in place right over the LCD monitor, so it feels more like you're using a regular video camera, and it really makes a big difference. In fact, it's a big enough difference that if you're going to be shooting a lot of DSLR video, it's totally worth the hundred bucks (if you just said, "100 bucks??" in disbelief, welcome to the wonderful world of video accessories. A good rule of thumb I use is this: whatever you think an accessory would cost if it was just for photography, add a zero at the end for video).

Learn the Popular "Rack Focus" Technique

©ISTOCKPHOTO/MAXIMKABB

One of the most popular DSLR video effects makes use of perhaps the best thing about DSLR—the shallow depth of field you can get with camera lenses. The trick is to focus on something close to the camera (so your distant subject is out of focus), and then slowly focus on your subject. (I posted a video of this effect on the book's companion website mentioned in the introduction.) This is basically an unfocusing, then refocusing effect (called "rack focusing" in movie terms). It's simple to do, but you have to do it smoothly because it's done by manually turning the focus ring on the end of the lens until your subject looks sharp. Start by choosing an f-stop that will give you a shallow depth of field, like f/2.8 or f/1.8, leaving autofocus on for now, and focus on an object close to you in the foreground (if the object isn't fairly close, you'll lose the shallow depth of field effect). Once it's in focus, turn the autofocus off (right on your lens) and start your video recording. After a couple of seconds, smoothly rotate the focus ring on your lens until your subject is in focus. It seems kind of anti-climactic when you're doing it, but it looks very cinematic in playback.

How to Make Rack Focus Even Easier

There's an accessory called "DSLR Follow Focus" (around $60), which adds a large focus knob to your lens. You can mark the point at which your subject, or other things in your scene, is in focus with a grease pencil, so you can easily turn the knob and focus right on any spot in the scene and know that it's sharp.

Adding Effects to Your Video in Your Camera

Although I generally don't recommend using any of your camera's built-in tint filters or effects (like B&W, Sepia, Cyanotype, etc.) for still images (you're always better off shooting in full color and then, if you want to try any of those effects, adding them later in Photoshop, Lightroom, iPhoto, or whatever photo editing software you have. That way, you've still got the original full-color image), when it comes to shooting digital video, that's one place where I think the built-in filters come in handy. Especially for people who don't want the hassle or complexity of learning a whole video editing program just to be able to apply these effects, but still want these types of looks. If that sounds like you, then just apply them in-camera right onto your video by simply turning them on before you shoot your video. On Nikon DSLRs, you turn on these effects by going under the Shooting menu, choosing Set Picture Control, and then going under Monochrome, and choosing the effect you want to apply to your video. On Canon DSLRs (like the 7D), press the Picture Style Selection button, choose Monochrome, and then choose the effect you want to apply.

Shooting DSLR Video Drains Your Batteries Faster

Because your camera is working continuously when you're shooting video (instead of just coming to life for 1/125 of a second here and there), it drains your batteries faster, so make sure you keep a spare camera battery with you.

Why You Want an External Mic

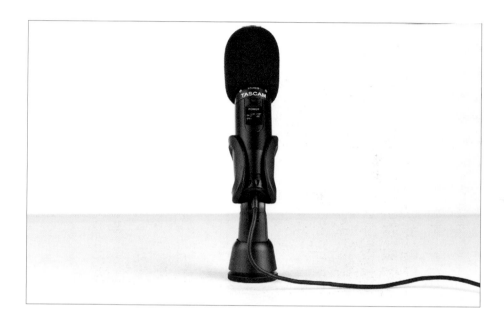

The built-in audio mic on your DSLR is…well…there's no polite way to say it, so let's just say if you actually want to hear what your subjects are saying, you should consider picking up an external mic that plugs right into your DSLR. Most DSLRs these days have a standard ⅛" mic jack (the size of a small headphone jack), so you can plug a better mic right in (see, even they know their mics are lame). You don't have to spend an arm and a leg to get a decent mic—the popular Tascam TM ST1 mic runs around $30, and it's small, lightweight, records in stereo, and is a big step up from your DSLRs built-in mic.

How to Break the DSLR Video Time Limit

Depending on which model of camera you have, you can shoot video for anywhere from 5 minutes to 12 minutes (and there are all sorts of conflicting opinions on why its limited to such a short time), but there's an easy way around it. If you pause your recording, even for just two seconds, it resets the video timer clock and you can start shooting again (so to shoot 36 minutes, you'd only have to pause twice, each time for just a second or two, and then you can keep right on shooting). Just pick a boring moment to pause.

Bad Audio = Bad Video

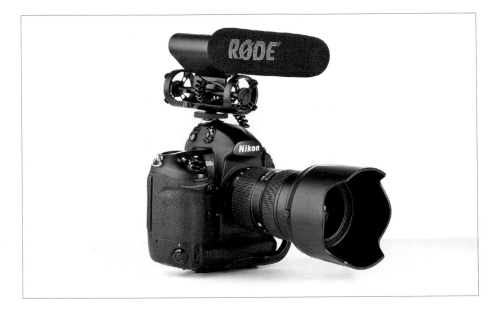

The quality and cinematic look of the video that today's DSLR cameras create is so good right out of the camera that you really don't have to work hard to make it look good— it's *gonna* look good. So what's the thing that's going to make your great-looking video come off cheap and amateurish? If it's anything, it's the audio. This is one big area that separates the pros from the amateurs—the pros have audio that matches the quality of the video, and if you have one without the other, it's not going to have that pro look in the end. Think of it this way: if you opened an Italian restaurant and you made your pasta fresh from scratch, would you then just open a jar of cheap spaghetti sauce and pour it on top? Of course not, because that cheap sauce would hide how great your handmade pasta really is. You have to have great pasta and a great sauce to make a pasta dish that's really special. It's the same way with video: it takes both parts—great video and great audio—to make a movie that's really special. So, if there's an area where you don't want to cut corners, it's the audio. If you can invest around $150, check out the Rode VideoMic shotgun mic, which mounts right on top of your camera or on a boom pole, and comes with a shock mount so you don't hear the rustling of the mic on the video as you move the camera. Nikon also has one, the ME-1, for $130. When you're ready to take your overall video quality up a big notch, this is the place to start.

Making Certain You're In Focus

Most DSLRs require you to manually focus on your subject when shooting video, and that's made even trickier by the fact that you're not looking through your viewfinder to focus—instead, you're using the LCD monitor on the back of your camera, and if you're subject isn't really large in the frame, there's a fair chance they'll be at least a little out of focus. So, since you're already looking at the LCD monitor before you start recording, why not use the zoom button (the little magnifying glass with the plus sign) to zoom in tight on your subject and make certain they're in really sharp focus before you hit the depth-of-field preview button (on a Nikon) or the Start/Stop button (on a Canon). Of course, don't forget to zoom back out before you actually start recording (you knew that, right?).

Don't Shoot Video Vertical

I see photographers do this all the time, because we're so used to shooting in portrait orientation for stills, and while portrait (tall) shots look great in photography, a tall, thin rectangle is not how people are used to seeing movies and, not only does it make your video appear significantly smaller onscreen, it kind of freaks people out to see video in that format. Just remember: when you're shooting video, stay wide.

Why You Need to Lock Your Exposure

Canon

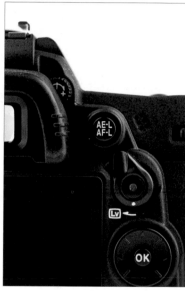

Nikon

When we're shooting stills in anything other than manual mode, we want the camera to examine each scene and pick the right exposure for what we're aiming at, and if we aim to the left or right, we expect it to adjust, right? Of course. While that works great for still images, it creates a disaster with video, because you don't want the brightness in the video changing every few seconds as you move the camera—it makes it look like the light in your scene is pulsating up and down, which is annoying as all get out. The way around this is to lock your exposure before you start recording, and that way your exposure will stay constant and you'll be side-stepping one of the biggest problems DSLR video shooters complain about. To lock your exposure, first get your exposure the way you want it before you start recording by aiming your camera at the scene, and then holding your shutter button halfway down to set the exposure. Now, on Canon cameras, you'll press-and-hold the AE Lock button (on the top right back of the camera, shown above on the left), and once it's locked, you can start recording. On Nikon cameras, it works best if you switch your metering mode to Center Weighted (it's the middle choice) before you press the shutter button halfway down to get your exposure set, so turn your Metering Selector on the top side of the camera to Center Weighted, then press the shutter button down halfway to set the exposure. Now, press the AE-L/AF-L button (shown above on the right), to lock that exposure and now you can begin recording without worrying about your brightness pulsating.

F-Stops Matter Here, Too, But…

Choosing your f-stop when shooting video matters just like it does when you're shooting stills—if you want the background to be soft and blurry (a shallow depth of field), then shoot at an f-stop like f/1.8, f/2.8, f/4, and so on, and if you want everything in focus, f/8 works great. But, there's something to keep in mind when shooting video, and that is: you can't just throw a flash up if you want to shoot at f/16 or f/22. If you want to shoot at f-stops like that (where everything's in focus for a very long range, like when you're shooting land-scape stills), you'll need to be outdoors in really bright light, or you're going to have some really dark video. That's why, most of the time, you'll be shooting at f/8 or a lower numbered f-stop—you need a lot of light for video, so those higher numbered f-stops are usually only available to you outdoors in the daytime.

Why You Need Fast Lenses for DSLR Video

Since you can't use a flash to light your subject, most (if not all) of the time, you'll have to use the available light where you're shooting, and unless you're shooting outdoors all the time, you'll need to use fast lenses (like f/4, f/2.8, or f/1.8) to be able to shoot in those low-light situations. Both Nikon and Canon make 50mm f/1.8 lenses that are in the $125 range, and when you go into low-light situations (like a church for a wedding), you can pop that 50mm f/1.8 on your DSLR and keep right on shooting.

How to Avoid "Flicker" While You're Shooting

If there are fluorescent or mercury vapor lamps visible in your scene (pretty typical in stores, warehouses, and offices), or if you see televisions or computer screens anywhere in your scene, then you're probably going to see some flickering or pulsating from either or both of these. It's caused by the flow of electrical current, but luckily it's easy to fix. First, check to see if your camera has a flicker fix control (for example, the Nikon D5100 has a Flicker Reduction option found under the Setup menu. When you choose Flicker Reduction, it has a number of different frequency choices—just try each one to see which one works best). If your camera doesn't have any type of flicker reduction, you can do it yourself by adjusting your shutter speed. For example, in the U.S., the electrical system is based on 60 hz, so we have to shoot at a shutter speed of 1/60 of a second (or any derivative thereof, like 1/120 of a second, or 1/180 of a second, and so on). In Europe, the electrical system is at 50 hz, so you need to shoot at a derivative of 1/50 of a second (like 1/100 of a second, 1/150, and so on). That should do the trick.

Want More of a "Film" Look?

By default, many cameras are set to shoot video at 30 frames per second, which is a pretty standard frame rate for video, but a trick the pros use to get more of a film look (and less of a videotape look) is to slow the frame rate down to 24 frames per second. To do this on Canon cameras (like a 7D), go to your Movie menu (or Settings-2 menu, under Live View/Movie Function Settings), and when you choose your Movie Recording Size, choose 1920x1080 Full HD and choose 24p as your frame rate. That's all there is to it. On Nikon cameras, except for the D4, your frame rate is already set to 24 frames per second, so you're good to go.

For a More Film-Like Look, Turn Off Your In-Camera Sharpening

By default, your camera applies sharpening to your images (except when you shoot in RAW mode, and when shooting video, you're definitely not shooting RAW, so it's applying sharpening). If you want a flatter, more "film-like" look, turn off this in-camera sharpening. On a Nikon, go under your Shooting menu, chose Set Picture Control, and then choose Neutral. On a Canon, press the Picture Style Selection button and then choose Neutral.

Don't Touch That Aperture

When we're shooting stills, if we think we need a different aperture, we just change it, right? But when you're shooting video, you don't ever want to change apertures while you're recording or you'll see a very obvious lighting change right in the middle of your clip, which is generally a big no-no in video circles. So, don't do this unless you want people pointing at you at video parties and whispering, "She changed apertures in the middle of a clip." Nobody wants that.

Why Zooming on Your DSLR Is Different

When you zoom in/out on a traditional video camera, the zoom is very smooth because it's controlled by an internal motor—you just push a button and it smoothly zooms in or out, giving a nice professional look. The problem is that there's no internal motor on your DSLR—you have to zoom by hand, and if you're not really smooth with it, and really careful while you zoom, you're going to wind up with some really choppy looking zooms. In fact, since it's so tough to get that power-zoom quality like we're used to with regular video cameras, there are a bunch of companies that make accessories so you can make it look like you used a power zoom, like the Nano focus+zoom lever from RedRock Micro. It's two pieces (sold separately, of course, because this is video gear and therefore a license to print money), but luckily, neither is too expensive. First, you need the focus gear, which is sized to fit your particular zoom lens, and that runs around $45, but that's just for focusing (very nice to have, by the way), but then you add this zoom handle to it, for another $35 or so (also worth it), so you're into both for only around $80, but it sure makes zooming smoothly a whole lot easier.

How to Use Autofocus for Shooting Video

As you've probably learned, many DSLR cameras don't autofocus when you're shooting DSLR video, so then it's a manual thing, but that doesn't mean you can't use Autofocus to help you out. The trick is to use Autofocus before you start shooting, so basically, you turn on Live View mode, but don't start recording yet—instead, aim your camera at your subject, press the shutter button down halfway to lock the focus, then move the Auto-focus switch on the barrel of your lens over to "M" (Manual) mode, and you're all set. Now, the only downside is if your subject moves to a new location (even if it's two feet away), you have to do this process again (luckily, it only takes a few seconds each time you do it, and you get pretty quick at it pretty quickly).

SHUTTER SPEED: 1/1600 SEC F-STOP: F/4 ISO: 4000 FOCAL LENGTH: 400mm | PHOTOGRAPHER: SCOTT KELBY

Chapter Eleven

Pro Tips for Getting Better Photos

More Tricks of the Trade for Making Your Shots Look Better

One day, while doing research for an upcoming talk I was giving on the history of American photography, totally by accident, I stumbled upon something I clearly wasn't supposed to find. It piqued my curiosity, so I kept digging around, and the more I dug, the more shocking what I uncovered became. Soon, I had no choice but to share what I had learned with a well-known top photographer, and after my solemn promise to protect his identity at all costs, he was willing to not only corroborate my findings, but he let me in on a truly startling, highly-guarded, and explosive secret—one that, once revealed, will likely have a devastating effect on our entire industry, but this is a story that must be told. Deep breath—here we go. First, you need to know that there is a secret council of photographers called the Zeta 7, founded in 1946 in Bensonhurst, New York, with the sole purpose of protecting a set of hidden camera settings, techniques, and camera functions which, when used together, create professional-looking images every single time. The Zetas only share these secret settings with their Zeta Brothers as a way of ensuring only Zeta members will be able to create truly amazing images. Each year, the Zetas induct seven more hand-picked photographers into their order during a ritualistic blood oath ceremony (supposedly held in an abandoned New York subway tunnel that runs directly beneath the B&H Photo showroom on 9th Ave. and West 34th St.), where they are sworn never to divulge the inner workings of the order. Then, and only then, are they allowed to don the ceremonial robes for their one-time, candlelight access to the "sacred settings scroll," which contains those secret settings to getting pro-quality images, and this is why only a select group of top pros seem to get these amazing images time after time. Interesting side note: According to one Zeta who was excommunicated from the order, the secret password to enter the Zeta meetings is, "It's not about the camera." True story.

Fit a Lot More Shots on Your Memory Card

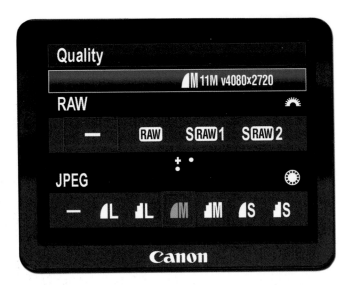

I mentioned back in volume 1 of this book series that, to have enough resolution to print a 16x20" print, you only needed an 8-megapixel camera. Of course, most folks will never print anything larger than an 8x10, so you could make the case that, for most photographers, 8 megapixels is actually overkill. That being said, what if you don't make prints at all? Today, most people's images wind up on the web, and if that's the case (and you shoot in JPEG mode), you might consider lowering the megapixels your camera shoots. Not the quality, just the size of the images. That way, you fit more images on your memory cards, you take up less space on your hard drive with your photos, and even Photoshop will run faster, because you're working with smaller file sizes. To do this on most Nikon DSLR cameras, go under the Shooting menu, under Image Size, and choose Medium. If you have a 12-megapixel camera, that still gives you an image size of 3216x2136 pixels, which is still more than enough resolution to print an 11x14" image. (Remember, this only takes effect if you shoot in JPEG mode, and make sure you keep your Quality setting on Fine.) On Canon cameras, on the Shooting 1 tab, go under Quality, and choose the first Medium choice, which on a 50D still gives you an 8-megapixel image (medium is even larger on a 5D or 5D Mark II).

> ### You Can Use Smaller RAW Sizes on Canon Cameras
>
> If you have a Canon DSLR, you can actually do this same trick on RAW images, as they offer Medium RAW and Small RAW. All the same features at half the size (or less).

Sneaky Trick When You Can't Use Your Tripod

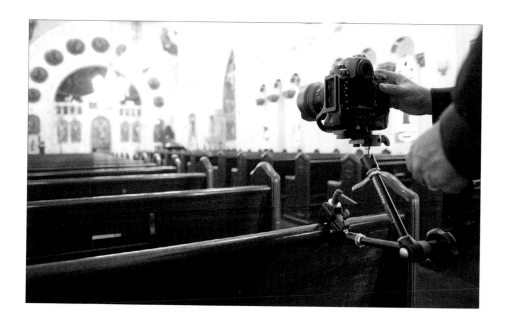

More and more places, like museums, observatories on top of tall buildings, train stations, and even cathedrals, have very strict rules about not using tripods, but so far I haven't found a single one that has a rule about using a Manfrotto Magic Arm and Super Clamp. You just clamp it on something (like a railing or a pew, for example), and it holds your camera steady so you can shoot in really low light. Security guards are totally perplexed by them, because there's nothing in their rules about accessory arms. In fact, if they approach you and ask, "What is this?" You can say something like, "Oh, this is a way for me to keep my camera still without having tripod legs sticking out where someone might trip." (See, you're looking out for them.) Of course, you could add, "I have to use this because I have shaky hands." However, I would never stoop to using this slightly modified response, "I have to use this to steady my camera because of a medical condition," because a line like that would probably work every single time. I'm just sayin'.

When Exposure Compensation Doesn't Work

I think one of the most important things a new photographer can learn about their camera is how to use exposure compensation, which is basically where you don't agree with how the camera exposed the shot. It thinks it did a great job, but when you look at the LCD on the back of your camera, you think the image looks too dark or too bright (both are pretty common, especially in tricky lighting situations). Whatever it did, it didn't nail the exposure. Luckily, you can override the camera (it thinks it's right; you know it's wrong) by using exposure compensation. You can learn more about how to do this for your particular camera on page 74, but one thing that catches a lot of photographers about exposure compensation is this: it doesn't work if you shoot in manual mode. It only works in modes where the camera is figuring out the exposure automatically (like when you shoot in aperture priority mode, shutter priority mode, or program mode). But, here's where the camera companies "gotcha!": the dial for exposure compensation still moves when you're in manual mode and shows you the minus or plus number, even though it's not actually doing anything. So, you'll be look-ing in your viewfinder and it says you're at –1 stop or up 2/3 of a stop, but then you take the image and it looks exactly the same. That's what happens in manual mode, so if you shoot in manual and your exposure doesn't look right, exposure compensation won't help. This one's totally on you (in other words, you'll have to adjust your aperture or shutter speed until the image looks right to you. That's why they call it "manual").

Avoid Signs Because They Draw the Eye

If you're like me, and you're worried about things distracting your viewer from the story or subject you want them to see in your photo, keep a sharp eye out for any printed signs or text that might appear in your photos. We're all mentally programmed to read signs, and unless the sign is the subject of your image, your viewers will automatically start reading the sign, instead of looking at your subject. I learned this tip a few years ago from Jay Maisel, and I've seen it play out time and time again, whenever I showed an image with a sign somewhere in it. Even if it was in the background, it seemed that within a split second of me showing the image, the viewer was reading it aloud. So, in short, try to compose your shots so signs or text don't appear in them unless you want them to be the first thing your viewer sees (and reads!).

The "Gotcha" of Using Picture Styles

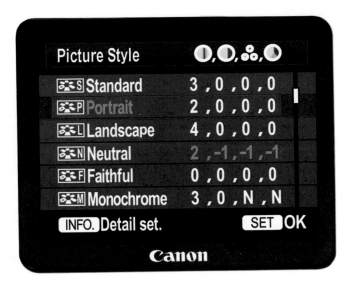

Picture styles, those in-camera color and contrast effects that let you, for example, have more vivid colors for landscapes, or a more neutral look for portraits, or a really vivid look for shooting in cities, etc., have a hidden "gotcha"—they don't get applied to your image if you shoot in RAW format. They only actually affect the image at all if you shoot in JPEG mode. What stinks about this is that, when you're shooting RAW, the preview you see on the LCD on the back of your camera is actually a JPEG preview, so you see the picture style being applied, even though when you open your RAW image in Photoshop or Lightroom, that picture style is long gone. If you shoot Nikon, and you shoot in RAW, but you really, really want to use these picture styles and actually have them applied to the image, you can buy Nikon's Capture NX program, which actually keeps the picture styles intact when you shoot in RAW. It runs about $130, so you have to really, really want to keep those picture styles in a bad, bad way. Of course, if you have Photoshop, Photoshop Elements, or Lightroom, you can use the camera profiles in Camera Raw's or Lightroom's Camera Calibration panel to apply these same picture styles to your RAW file.

Rotate Tall or Rotate Image or Both?

When it comes to rotate settings in your camera, there are actually two different ones that do two entirely different things, and knowing which is which can save you a lot of frustration. Rotate Tall (on Nikons, under the Playback menu) means that when you shoot vertical (tall), the camera will rotate the image on the LCD on the back of your camera (that way, you don't have to turn your camera sideways to see tall images). The other rotate setting is called Rotate Image (under the Setup menu), which means it embeds the orientation of the image right into the file, so when you open the image in Lightroom, or Bridge, or Photo Mechanic, etc., it automatically rotates the thumbnails of tall images so they don't come in sideways and have to all be manually rotated by you. On Canon cameras (like the 50D), go under the Set-up 1 tab, and choose Auto Rotate. If you choose On with an icon of a camera and computer monitor beside it, it rotates the photo both on the LCD on the back of your camera and your thumbnails when you import the photos onto your computer. If, instead, you choose On with just the computer monitor beside it, then it only rotates the image on your computer (your camera will still show it on its side). If you choose Off, it means there's no rotation at all—everything stays on its side, on your LCD and on your computer.

Reducing Noise in Low-Light Shots

If you shoot in low-light situations or at night, it's almost a lock that you're going to have some noise in your image (little red, green, and blue dots—kinda like film grain, but not nearly as endearing). Anyway, we used to have to buy plug-ins to get rid of noise, but in Photoshop CS5's (and higher) Camera Raw or Lightroom 3 (and higher), the noise reduction built right in is so good, we can pretty much skip using noise reduction plug-ins altogether. If you shoot in RAW, it works really brilliantly, because unlike most plug-ins, it removes the noise while the image is still a 16-bit RAW image. If you shot in JPEG mode (so it's already 8-bit), you can open that JPEG in Camera Raw or Lightroom and still use its Noise Reduction, but it's not quite as robust (because now you're kind of using it as a plug-in). To find this noise reduction, open your image in Camera Raw, then click on the Detail icon. In Lightroom, go to the Detail panel in the Develop module. There are five sliders in this section, but we're only going to focus on the two most important ones: Luminance and Color (you can leave the others set at their defaults). The Luminance slider is kind of the overall noise reduction amount slider—the more noise you see, the farther you'll need to drag it to the right, but be careful, if you drag it too far, your image will start to look soft and lose contrast. Without going into too much detail (this isn't a Photoshop book, after all), if you increase either the Luminance or the Color sliders and things start to look too soft, or you lose detail, or the colors look desaturated, that's what the other three sliders are for—to help bring some of those back (the names of those sliders help you figure out which one is which).

What People Looking at Your Photos See First

Knowing what your viewer's eye is going to see first in your photo can really help a lot in planning it out. Basically, the human eye is drawn to the brightest thing in the image, so if your subject is in the foreground, but behind him is a window with bright sunlight, their eye is going to go there first (not generally what you want). So, knowing that, you can recompose or relight the photo to make sure the brightest thing in the photo is precisely where you want your viewers to look. After the brightest thing, next they look for the sharpest, most in-focus thing, so if there's a very shallow depth of field, they lock right onto whatever's in focus (hopefully, your subject). Knowing these two things (where people looking at your photos are going to look first, and then where they'll look next) can really help you in creating photos where your viewer's eye goes right where you want it, by making sure that brighter and sharper areas don't appear somewhere else in your photos.

Keeping Your Camera Info from Prying Eyes

If you're going to be sharing your photos on the Internet, you're going to be sharing a lot more than your photos. That's because your camera embeds a ton of information about your camera gear, including your camera's make and model, the lens you used, your f-stop and shutter speed, and depending on the camera, perhaps the exact location where you took the photo, and even your camera's serial number (this info is called EXIF data or camera data). If you don't want strangers to have all this inside info on your camera and your photos, here's what to do: copy-and-paste your image into a new blank document. That way, it doesn't have any background info at all. To do that: Open your image in Photoshop (or Photoshop Elements) and press Command-A (PC: Ctrl-A) to select the entire image. Now, press Command-C (PC: Ctrl-C) to copy your photo into memory. Go under the File menu and choose New, and click the OK button (don't change any settings—just click OK). Now go under the Edit menu and choose Paste (or press Command-V [PC: Ctrl-V]) to paste your copied photo into the new blank document (and, of course, this new blank document has none of your camera information embedded into it). Lastly, since your image pastes in as a layer, you'll want to flatten your image by pressing Command-E (PC: Ctrl-E), and then save your document in whichever file format you like (I usually save mine as a JPEG with a quality setting of 10). That's it—your secret's safe! :)

Why JPEGs Look Better Than RAW Images

JPEG

RAW

I know what you're thinking, "I've always heard it's better to shoot in RAW!" It may be (more on that in a moment), but I thought you should know why, right out of the camera, JPEG images look better than RAW images. It's because when you shoot in JPEG mode, your camera applies sharpening, contrast, color saturation, and all sorts of little tweaks to create a fully processed, good-looking final image. However, when you switch your camera to shoot in RAW mode, you're telling the camera, "Turn off the sharpening, turn off the contrast, turn off the color saturation, and turn off all those tweaks you do to make the image look really good, and instead just give me the raw, untouched photo and I'll add all those things myself in Photoshop or Lightroom" (or whatever software you choose). So, while RAW files have more data, which is better, the look of the RAW file is not better (it's not as sharp, or vibrant, or contrasty), so it's up to *you* to add all those things in post-processing. Now, if you're pretty good in Photoshop, Lightroom, etc., the good news is you can probably do a better job tweaking your photo than your camera does when it creates a JPEG, so the final result is photos processed just the way you like them (with the amount of sharpening you want added, the amount of color vibrance you want, etc.). If you just read this and thought, "Man, I don't even use Photoshop..." or "I don't really understand Photoshop," then you'll probably get better-looking images by shooting in JPEG and letting the camera do the work. I know this goes against everything you've read in online forums full of strangers who sound very convincing, but I'll also bet nobody told you that shooting in RAW strips away all the sharpening, vibrance, and contrast either. Hey, at least now ya know.

When You Don't Need to Shoot on a Tripod

In volume 1 of this book series, I had a whole chapter about how the pros get really sharp images, and one of their secrets is that they're willing to use a tripod when most photographers won't. In fact, they're pretty freaky about it, but that's one reason why their shots are so tack sharp. So, do these pros ever not shoot on a tripod? Yup, and there are two occasions where it's really not that necessary: (1) When you're shooting flash. The super-short duration of your flash of light freezes your subject, so you don't have to worry too much about any movement in your image (which is why you don't often see tripods in the studio). And, (2) when you're shooting outdoors on a bright sunny day. That's because your shutter speed will be so fast (probably around 1/4000 of a second or higher) that you could almost throw your camera in the air while taking a photo and it would still take a sharp shot (although I wouldn't recommend testing that theory).

What to Do If Your Image Isn't Quite Good Enough to Print

If you've taken a shot that you really, really love, and it's maybe not as sharp as you'd like it to be, or maybe you've cropped it and you don't have enough resolution to print it at the size you'd like, I've got a solution for you—print it to canvas. You can absolutely get away with murder when you have your prints done on canvas. With its thick texture and intentionally soft look, it covers a multitude of sins, and images that would look pretty bad as a print on paper, look absolutely wonderful on canvas. It's an incredibly forgiving medium, and most places will print custom sizes of whatever you want, so if you've had to crop the photo to a weird size, that usually doesn't freak them out. Give it a try the next time you have one of those photos that you're worried about, from a sharpness, size, or resolution viewpoint, and I bet you'll be amazed!

When to Switch to Spot Metering

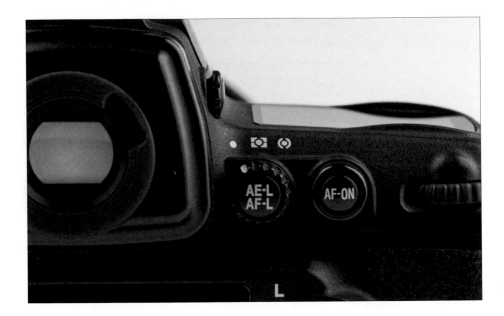

I get a lot of questions about when to switch to Spot metering (a metering mode that measures just one small area of the photo). I can tell you that 99% of the time, I leave my camera set to Matrix (or Evaluative on a Canon) metering (the standard metering mode that does an amazing job of getting you good exposures without having to break a sweat). However, there are times (few though they are) where I need to switch to Spot metering and those are where there's something in the image that I'm worried about being properly exposed. Now, do I worry about something being properly exposed when it's well-lit? Nope. Usually, it's when something that's really important is in bad light—like a shadow area of my photo. So, in short, when there's something in the photo whose exposure needs to be right on the money, I switch to Spot metering just for that shot, and then I switch back to Matrix (or Evaluative), which works wonderfully in 99 out of 100 situations.

Try Cinematic Cropping for a Wide-Screen Look

Last year, I came up with a style of cropping photos that kind of approximates what a wide-screen movie looks like onscreen (which is why I call it "cinematic cropping"). It really gives your image that wide-screen, almost panoramic look, and I find myself using it more and more. Luckily, it's easy to crop like this in either Photoshop, Camera Raw, or Lightroom. We'll start with Photoshop. Step One: Click on the Crop tool, then up in the Options Bar, in the Width and Height fields, for Width, enter 2.39, and for Height, enter 1. That's it. Now when you drag out the Crop tool over your image, it will be constrained to those cinematic crop proportions. In Camera Raw, just click on the Crop tool and, from the pop-up menu that appears, choose Custom Crop. When the dialog appears, from the pop-up menu, choose Ratio, and then type in 2.39 in the first field and 1 in the second. Now your Crop tool will be constrained to the cinematic crop proportions. Lastly, in Lightroom, press R to get the Crop Overlay tool and, from the pop-up menu to the immediate left of the Lock icon, choose Enter Custom. Enter 2.39 in the first field, and 1 in the second field, and click OK. Now your Crop Overlay tool will be constrained to the cinematic crop proportions, so just drag it out over your image and bring the cinematic feel to your images.

Sharpening Your Images for Print

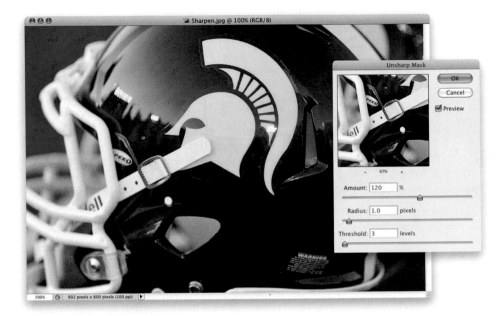

This should really be called "Oversharpening Your Images for Print in Photoshop," because that's pretty much what you do. Here's why: after you get your sharpening so it looks good onscreen, when you print your image, you'll think it looks a little soft and that's because you lose some of the sharpness you see onscreen during the printing process. So, to get around this, we oversharpen our images in Photoshop. Here's what to do: First, get the sharpening so it looks good onscreen (I use Photoshop's Unsharp Mask filter, and if you're looking for a starting place, try these settings: Amount: 120%, Radius: 1, and Threshold: 3). Now, if that looks good onscreen, start slowly dragging the Amount slider to the right, which increases the amount of sharpening, and as soon as you think "Ewwww, that's too sharp…" just stop. Don't backtrack the Amount slider— just stop. Now, I know you're looking at your screen and you're thinking, "This looks a bit too sharp" and if that's what you're thinking, your sharpening is probably right on the money. I know it's hard to print something that looks too sharp onscreen, but you'll have to trust that a little too sharp onscreen means a little just right in print. Also, if you're going to need to use this same image on the web and in print, before you apply this sharpening for print, duplicate the Background layer and apply your sharpening just on that layer (and rename this layer "Sharpened for print," so you'll know it's oversharp- ened). That way, you'll still have the original Background layer that's not oversharpened.

How to Rescue a Damaged Memory Card

Memory cards go bad. It happens. However, it never happens when you took a bunch of experimental photos that really don't matter. They only go bad when you shoot some-thing really Important. I believe, on some level, they sense fear. Anyway, if the unthinkable happens (you put your memory card into your card reader, and it appears to be blank when you know it's not), there are downloadable software recovery programs (some of them even free) that do a pretty amazing job, so all is usually not lost. However, if this happens, stop what you're doing, and start your recovery process immediately for the best chance of getting your images back (in other words, don't put the card back in the camera and keep shooting. Don't reformat the card. Don't do anything—just launch your recovery software right away). As for the recovery software itself, I've used SanDisk RescuePro software (you can download a free demo version at www.lc-tech.com/), and it has worked well (even on non-SanDisk cards), but my favorite is Klix, and maybe only because it's rescued the images on every card that's ever died on me (a friend turned me on to it after it saved his hide, too).

Keeping from Accidentally Erasing an Important Memory Card

If your camera uses SD memory cards, there's a small switch on the cards themselves that keeps them from being accidentally erased, or reformatted, or...well...anything. So, if you know you've got a card of shots that you want to protect, just pop the card out, slide the switch to Lock, and you're set.

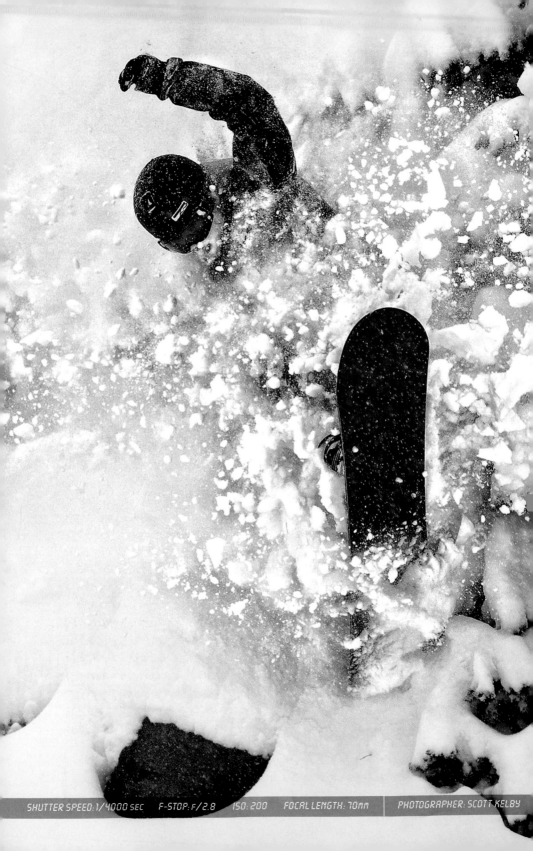

SHUTTER SPEED: 1/4000 SEC F-STOP: F/2.8 ISO: 200 FOCAL LENGTH: 70mm PHOTOGRAPHER: SCOTT KELBY

Chapter Twelve

Yet Even More Photo Recipes to Help You "Get the Shot"

The Simple Ingredients to Make It All Come Together

The most popular chapter in the previous three books in this series has been this chapter—Photo Recipes—and I have to tell you, as an author that really makes me happy, because I always like to add something at the end of my books that takes it up a notch. Kind of the "icing on the cake," or the "crème de la crème," or the "maple syrup on the spaghetti." Anyway, these photo recipes have become so popular that I actually created a DVD/book combo called (wait for it...wait for it...) *Photo Recipes Live: Behind the Scenes*, where I take the same photos I featured in volume 1 of this book series and recreate how to do them live, from scratch, all filmed in a very cool New York City studio. It turned out to be a huge hit, but of course, it would be inappropriate for me to mention that here (or that it's published by Peachpit Press, ISBN: 0-321-70175-5, street price around $30), so I won't mention it or its hugely successful follow-up, *Photo Recipes Live, Part 2: Behind the Scenes* (also published by Peachpit Press, ISBN: 0-321-74971-5, also street-priced around $30). Plugging those would be out of the question, so if you think that for one minute I'm going to mention that both of these have been made available by Peachpit Press (Pearson Education) as downloadable apps for the iPad (where they both only cost $19.99, which is insanely cheap by the way), then man are you way off. You see, I think that using what should be an utterly nonsensical page in the book and turning that into a thinly veiled advertisement for other training products I've produced, and then using that as a springboard to promote my daily blog at www.scottkelby.com, where you can find out when and where I'm teaching the live seminars I do for http://kelbytraining.com/live, well, you're just not going to see that type of stuff from me, because frankly, I deplore it when other authors do stuff like that. Not me, mind you. Just other authors. ;-)

The Recipe for Getting This Type of Shot

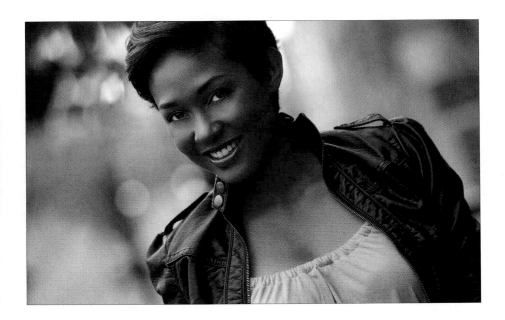

Characteristics of this type of shot: A soft, glamorous look, with the background way out of focus, and a soft-creamy look to the entire image.

(1) For this look, you're going to need a telephoto lens (this was shot with a 70–200mm lens out at around 200mm). By zooming in tight like this, it helps to put the background out of focus, but that alone isn't enough to make the background this out of focus. The other thing you need to do is shoot in aperture priority mode and use the smallest number f-stop you can, like f/2.8 or f/4 (if your lens will let you go that low).

(2) This is actually a natural-light shot, but the reason the light is so beautiful is because it's taken outdoors very late in the afternoon, maybe an hour and a half before sunset. To give the shot a bit more energy, tilt the camera at a 45° angle when you take the shot.

(3) To make the light even softer, have a friend hold up a 1-stop diffuser between your subject and the sun (it's large, round, and basically looks like a reflector, but instead of being silver or gold and reflecting light, it's white and translucent, so it allows some of the sunlight to come through, but spreads and softens it quite a bit). Have them hold the diffuser as close to your subject's head as they can get without it actually being in your frame, and it creates the beautiful, soft, diffused light you see here (the diffuser is above the left side of her head at a 45° angle). These diffusers are collapsible just like a reflector, and they're fairly inexpensive, too.

The Recipe for Getting This Type of Shot

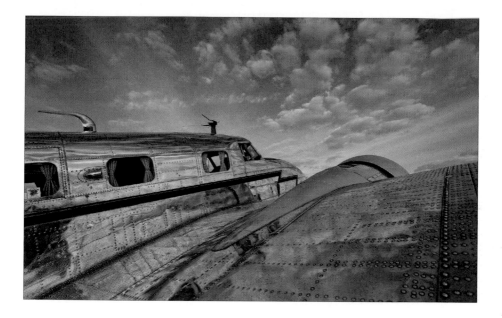

Characteristics of this type of shot: A sweeping wide-angle shot that makes the clouds look like they're arcing out from the center.

(1) You need to use a very-wide-angle lens (the wider the better), so the minimum would be an 18mm, but ideally a little wider, like a 14mm or 12mm. When you go this wide, it really spreads the clouds out, which is part of the effect.

(2) To give the subject that larger-than-life look, get down really low (I was on my knees when I took this shot) and get really close to the subject (I was right at the edge of the wing). This exaggerates the size of your subject when you shoot up close like this with a wide-angle lens.

(3) To get soft light like this on the plane and still have a blue sky, you'll need to shoot this just after sunrise, which means you'll probably be shooting in lower light than you would even an hour later. So, since you're shooting at a slower shutter speed, you'll want to be on a tripod. That way, your image is tack sharp.

(4) Lastly, to make the chrome really pop on this image, I used the Photoshop plug-in Nik Color Efex Pro (download the free demo from www.niksoftware.com), and I used their built-in preset called "Tonal Contrast."

The Recipe for Getting This Type of Shot

Characteristics of this type of shot: Dark, dramatic lighting that lights your subject's face, but then falls off very quickly (notice how the light falls off to black as it gets near the bottom of the photo, which adds to the drama).

(1) To get this type of shot, you just need one light with a small-to-medium-sized soft-box, up high and aiming straight down at the floor (think of aiming the light like it's a showerhead—tilted down as far as it will tilt on a regular light stand). Keep the power on the light about as low as it will go, since it will be so close to the subject.

(2) Start by positioning the light directly beside your subject, then slide it forward just a foot or two, and then angle it back toward your subject. Since this is only lighting one side of your subject, make sure your subject turns their body toward the light and keeps their chin up a bit, as well.

(3) To add to the drama, either use black seamless paper or position your subject at least 8 to 10 feet from the background, so your main light doesn't spill onto the background (that way, as long as it's dark in the room where you're shooting, the background will still be black). Lastly, to get the "hair in the face" look, have your subject bend over, then give them a cue to snap back up straight and shoot while their hair is still moving. It'll take a few tries to get a good shot, but luckily, the film is free. :)

The Recipe for Getting This Type of Shot

Characteristics of this type of shot: A dramatic sunset shot where your subject is lit with a single off-camera flash and the light falls off quickly from their face.

(1) The key to this shot is turning your subject into a silhouette, and then using the flash to do all of the front lighting for them. Position your subject so the setting sun is behind them. To see both your subject and a lot of the rest of the scene, use a wide-angle lens and put your subject off-center to the left or right (but don't get them too close to the edge or they'll distort).

(2) Next, your job is to make the sky much darker than it really is. Start by making sure your flash is turned off, then switch your camera to shutter priority mode (S), and set your shutter speed to 1/125 of a second. Now, take a photo and look on the LCD on the back of your camera to see what f-stop your camera chose to make a normal exposure of the photo (let's say it reads f/5.6). Switch to manual mode (M), set your shutter speed to 1/125 of a second, then enter an f-stop that is at least 2 stops darker than what it just read (so, if you were at f/5.6, try f/10 or f/11). This makes the sky *much* darker than it would be.

(3) Take another test shot, and now your subject should be a solid black silhouette against the setting sun. Turn your flash on and keep your flash power *way* down low (you only need a little bit of light), and take your shot. Also, either put an orange gel in front of your flash or change your White Balance to Cloudy.

The Recipe for Getting This Type of Shot

Characteristics of this type of shot: A "beauty style" shot with soft, bright light that limits the amount of shadows on the face.

(1) There are just two lights on the subject: the main light is a beauty dish that's directly in front of the subject, but up about two feet above her face, aiming down at her at a 45° angle. The other light is a large softbox (although the size doesn't really matter), aiming up at her at a 45° angle. Position the camera height right at her eye level.

(2) To keep everything in focus, from front to back, you'll need to use an f-stop that holds details (like f/11) and a long enough lens (like a 200mm) to give nice perspective.

(3) To make the background pure white, you'll need to aim a single strobe at it. It can be a bare bulb with a reflector (well, that's what I used anyway), and put it about 4 feet from the background, down low on a light stand, aiming upward at the background.

(4) If you don't have three lights, then use a reflector panel for the bottom light instead— just have your subject hold it flat at their chest level, as high as possible without being seen in the frame.

The Recipe for Getting This Type of Shot

Characteristics of this type of shot: An action sports shot with the motion frozen, a larger-than-life perspective, and with a popular sports special effect to finish it off.

(1) The key to this shot is getting a low perspective with a wide-angle lens, like a 14mm or 12mm lens, and then literally lying on the ground, shooting up at the subject (in this case, a snowboarder).

(2) This was taken in the middle of the day, in direct sunlight, in aperture priority mode, at f/2.8, and at that wide-open an f-stop, you get around 1/4000 of a second, which is more than enough to freeze the athlete in mid-air (you only need around 1/1000 of a second or so to freeze action). Because your shutter speed is so fast, you can hand-hold a shot like this, no problem (plus, it would be really hard to pan along with the snow-boarder if you were on a tripod).

(3) To get that "blown-out" special effect look, you can use one of the built-in presets in the Photoshop plug-in Nik Color Efex Pro from www.niksoftware.com (you can down-load a fully working demo version from their site). The particular preset I used here is called "Bleach Bypass" and it replicates a popular traditional darkroom effect.

The Recipe for Getting This Type of Shot

Characteristics of this type of shot: A soft, misty landscape with lots of depth and dimension.

(1) To get a shot like this, you have to either get up early and be in position before dawn (that's when this shot was taken) or shoot it late in the day, right around sunset. The foggy mist you see is a big part of landscape photography—it's called luck. You can increase your luck by visiting the same location more than once. This was taken the second day of shooting in the exact same location—the previous day had no mist whatsoever.

(2) This is shot in fairly low light (maybe 30 minutes after sunrise), so you'll need to be on a tripod to keep your camera still enough for a really sharp shot. You'll also need to use a cable release, so you don't introduce even a tiny bit of vibration by touching the camera when you press the shutter button. Also, shooting from a low perspective gives the shot its "bigness," so put your tripod down so low you have to shoot on your knees.

(3) To have detail throughout the image, I recommend shooting at f/22, an ideal f-stop for telling a big sweeping story. Also, to add visual interest, don't put the road in the dead center of the photo (because that's dead boring—notice how it's cheated over to the left a bit?) and don't put your horizon line in the middle of the photo, because that's what your average person would do, and you don't want your images to look average.

The Recipe for Getting This Type of Shot

Characteristics of this type of shot: A dark, gritty, tone-mapped HDR shot taken on a moving boat.

(1) Part of the art of shooting any HDR photo is finding an image that makes a good HDR image. Anything with a wide range of brightness (the dark interior of the boat, versus the bright outdoors), along with features that have a lot of texture (note the wood floor, rope, the old metal on the boat, the life preserver, and the rusty boat parts that just scream, "Make me an HDR shot!"), generally works well.

(2) Because the boat is moving, you're going to need to steady yourself by leaning on a pole or a railing. You're going to need at least three bracketed frames to create a shot like this (see page 137)—one normal exposure, one that's 2 stops darker, and one that's 2 stops brighter. Because the boat is moving, you're going to need to shoot this same exact scene over and over, and hope that you have one set of shots where all three (or five) shots are in focus. Every set won't be, but just remember, you only need one. Don't be afraid to raise the ISO a little to get a faster shutter speed.

(3) Once you've got a set in focus, you'll need to combine those bracketed photos into one single HDR image using either Photoshop CS5's built-in HDR Pro or a Photoshop HDR plug-in (see page 147) and add the tone mapping that gives it that "HDR'd" look.

The Recipe for Getting This Type of Shot

Characteristics of this type of shot: A bright, sunny shot with the sun clearly visible, but your subject isn't lost in the shadows.

(1) This is a very easy shot to pull off—you just need a simple pop-up reflector. Position your subject so the sun is behind them or to the side (in this case, it's beside her, but when she faces the camera, she's fully in shadows. That's what the reflector panel is for—to bounce some of that sunlight back into your subject's face). The reflector should be to the left of you, held up high over the head of a friend or assistant and angled toward your subject.

(2) This was taken on a beach, but the beach wasn't very pretty at all, with lots of vegetation right at the shoreline. So, the trick is to get down low, very low—lying down, in fact—and shoot upward at your subject with a wide-angle lens. Make sure you put your subject to one side or the other—don't center her.

(3) This is going to sound silly, but if you're shooting outdoors, buy a long veil. You'll thank me, because if any tiny bit of wind comes along, it does beautiful things all by itself. If there is no wind, create your own using a second reflector panel—literally have a second friend (or assistant, or passerby) fan your subject with that large reflector. It doesn't take much to make that veil take flight, and it creates a beautiful look.

The Recipe for Getting This Type of Shot

Characteristics of this type of shot: A soft-light landscape with smooth, silky water and lots of depth and dimension.

(1) To get soft light like this, you need to shoot about 30 minutes before sunset, or during a very overcast day (or, ideally, both). Here's why: you're going to need to use a slow shutter speed to make that water smooth and silky, so an f-stop like f/22 or even f/32 (if your lens will go that high) would be great.

(2) Because you're using a slow shutter speed (shoot this in aperture priority mode—set your f-stop to f/22 and your camera will pick a slow shutter speed), of course you're going to need to be shooting on a tripod, and I would recommend a cable release, as well. If you have a neutral density filter (an ND filter; see page 90), you can put it on your lens to darken the scene and make your shutter speed even longer (for a scene like this, just a 2- or 3-stop ND would do it). If you don't have an ND filter, just put a polarizer on your lens—it will darken the scene and slow things down, as well.

(3) The compositional key here is to make the rocks in the photo the stars of the show. Make them the subject and compose the scene, so they're right down in front. The way to shoot this, without risking life and gear by getting right in front of the stream, is to shoot it safely from the shore with a telephoto lens and close in tight on the rocks.

The Recipe for Getting This Type of Shot

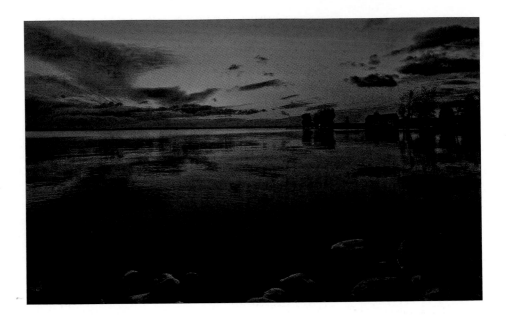

Characteristics of this type of shot: A sweeping landscape scene with a clear foreground, middle ground, and background.

(1) As you can tell, this is going to be a sunset or dawn shoot (pretty standard for great landscape photography), but the key to this shot is the composition. What makes a shot like this work is those rocks in the foreground of the shot. Without those rocks, it's just another shot of a lake. You need those rocks to anchor the shot with a foreground, so your shot has that depth that only happens when you have all three things in place: a foreground (the rocks), the middle ground (the lake, the trees to the right of center, and the boat house), and then the clouds in the background.

(2) Dawn or dusk shots like these always need to be shot on a tripod with a cable release to limit any vibration, so everything is tack sharp. To get those rocks in the shot, you need a very-wide-angle lens, like a 12mm or 14mm ideally (although an 18mm would still work), and you have to splay your tripod legs out and get down really low to capture those rocks at that low perspective. The best thing to do is sit on the rocks and get that tripod as low as it can go. Yes, it makes that big a difference.

(3) To keep everything in focus, from front to back, use an f-stop like f/22, which Is perfect for these types of shots. Now, keep your fingers crossed for a cloudy morning.

The Recipe for Getting This Type of Shot

Characteristics of this type of shot: A dramatic corporate portrait with an editorial cover-shot look to it, with a fast falloff of light, where the subject's face is lit, but then it falls off to dark very quickly.

(1) This is an amazingly simple, one-light shoot. The light is a studio strobe with a beauty dish that's about 1 foot directly in front of the subject, but up about 2 feet above his head, aiming back at him at a 45° angle. That's it.

(2) Because this is supposed to be a dramatic portrait, you don't want to kill him with light, so keep the power of your strobe just about all the way down (if you're using a hot shoe flash instead, switch the flash to Manual mode and use ¼ power, and then see if it needs to be a tad brighter or if that's okay).

(3) Your subject isn't moving, and you're using flash, so you don't have to shoot this on a tripod. I would recommend shooting in manual mode. For your starting place settings, try f/11, so everything is perfectly in focus, and set your shutter speed to ¹⁄₁₂₅ of a second (that way, you don't have any sync speed issues). Lastly, move your camera's focus point directly onto his eye (the one closest to the camera), press-and-hold your shutter button halfway down to lock the focus, and keep it held down. Now, compose the shot the way you want (here, I put him way over to the right) and take the shot.

The Recipe for Getting This Type of Shot

Characteristics of this type of shot: A location shoot with hot shoe flash, taken in bright, harsh mid-day sun.

(1) When shooting in the mid-day sun, the first thing to do is place the sun behind your subject (as seen here). At this point, your job is to make the sky behind your subject darker than it really is. To do that, start by turning your flash off. Then, switch to shutter priority mode, set your shutter speed to ¹⁄₂₅₀ of a second, and take a shot. Now, look at the photo on the back of your camera and make note of the f-stop your camera chose at that shutter speed.

(2) Switch to manual mode, enter ¹⁄₂₅₀ of a second for your shutter speed, then enter an f-stop that's 2 stops darker than what your camera chose in the previous shot (your flash is still turned off at this point). Let's say your f-stop was f/8. You'll need to change it to f/11 or f/13. Now, take another shot. The sky should be darker and your subject should be a backlit silhouette.

(3) Turn on your hot shoe flash and crank it up to full power. Make sure your flash has something in front of it to soften the light from it (a small softbox, a shoot-through umbrella, etc.). Move that flash in close to your subject (just outside your frame), then get down low on one knee with a wide-angle lens, and take a test shot. If the flash is too bright, lower the power and try again, until the light looks natural.

The Recipe for Getting This Type of Shot

Characteristics of this type of shot: A mixture of natural light and a strobe create dimension and a feeling that the shot is all natural light.

(1) This is one you can try in the doorway of a church, but make sure the doors are pulled back enough so that you don't see them (this was a double-door opening here). Ideally, you'd want to find a door that is not facing directly into the sun, and then place your bride just inside the door, as seen here. Since there's no harsh light falling directly on her, the light is soft (like window light), but at the same time, it's kind of flat, which is why we want to add a strobe on one side to add dimension.

(2) The strobe, with a square 27" softbox, is just off the right side of the photo and behind the bride at a 45° angle, and it adds just enough light to make it look like natural light streaming in through a window.

(3) The strobe is running off a battery pack (it's often hard to find convenient power outlets in a church), is connected to a monopod (held by a friend), and is up higher than the bride, aiming down at an angle, like the sun would aim. To get the background out of focus, shoot at an f-stop like f/2.8 or f/4, if possible (use the lowest number you can). We generally shoot strobes in manual mode and, to make sure the strobe stays in sync with your camera, set your shutter speed at $\frac{1}{125}$ of a second.

The Recipe for Getting This Type of Shot

Characteristics of this type of shot: An HDR shot taken inside a dimly lit church, aiming straight up to capture the detail in the ceiling.

(1) This is trickier than it looks because: (a) most buildings that have a ceiling you actually want to shoot won't let you use a tripod; and (b) even if you could use a tripod, it's not easy to set one up with your camera aiming straight up (in fact, for many, it's impossible), so this is one indoor HDR shot you often have to hand-hold.

(2) Hand-holding in a dark church means you're going to need to raise the ISO quite a bit, or one or more of your frames is going to be blurry. Also, you won't be able to shoot at f/8 when it's kind of dark like this, so use the lowest number f-stop you can (in this case, it was f/3.5).

(3) To get this sweeping of an expanse, this was shot with a 10.5mm fisheye lens, but you could get almost as much from a 12mm or 14mm lens. The problem isn't how wide the lens is; the problem is keeping it still while you're taking the shot.

(4) You can get step-by-step details in Chapter 9, but set up your camera to shoot in burst mode and then turn on Exposure Bracketing. Gently press-and-hold the shutter button and hold as still as you can until all three (or five) exposures are complete. If there's anything to lean against to help steady yourself, that will make a big difference. To get the HDR look, you'll need to compile the bracketed frames into one single image (see page 147) and then finish them off in Photoshop or Photoshop Elements.

The Recipe for Getting This Type of Shot

Characteristics of this type of shot: Still, glassy water and a sweeping landscape.

(1) The key to this type of shot is to shoot it at dawn or just after dawn, because that's the most likely time to find glassy water with reflections like this. Literally an hour or so later, and in many cases, you will have missed your chance as the winds pick up and the water gets choppy. (*Note:* In this location, the water was only still right around dawn—by 10:00 a.m., it was so choppy you wouldn't want to shoot it even if the light was good.)

(2) Of course, in the low light of dawn, you'll need to be shooting on a tripod, using a cable release to minimize vibration, and you'd shoot at f/22 to take it all in.

(3) Besides the still, glassy water, what makes this shot is the lone red canoe off to the left. It helps to make up for the fact that there's nothing at the bottom of the frame to act as a foreground element. The red pulls your eye and gives the shot some visual interest, but it's still not as strong as a foreground element. Your job when composing a shot like this is to position your composition so the canoe appears in an interesting place in the photo (like off to the left). I could have just as easily walked to the left a bit and put that canoe right in the center of my image, which would have made it too obvious and drained all the energy out of the composition with its placement.

The Recipe for Getting This Type of Shot

Characteristics of this type of shot: The shadowless look of a ring light without the dark shadow glows and overly punchy light.

(1) If you want all the good stuff of the ring-light look (bright, fashion-looking lighting) without the halo shadows and super-punchy, not particularly flattering light, just position a very large softbox directly in front of your subject, aiming straight back at them (don't tilt it—it should be flat, straight up and down).

(2) Position your subject in front of a white seamless paper background (the light from the front light will light the white seamless since it's aiming directly at it, so don't position your subject any farther than about 4 to 6 feet in front of the softbox).

(3) Now, you are actually going to stand in front of that large softbox (one reason why it needs to be large), and then squat down a little so you are at your subject's eye level and the only part of you that is sticking up in front of the softbox is your head.

(4) Shoot in manual mode and use f/8 or f/11, so everything is perfectly in focus, and set your shutter speed to $\frac{1}{125}$ of a second. Aim your focus point at the eye closest to the camera, then press-and-hold your shutter button halfway down to lock the focus. Now, compose the shot the way you want and shoot. Start with your strobe at ½ power and see if that's bright enough. If not, crank it up a bit until it looks like what you see above. I also added the Bleach Bypass filter in Nik Software's Color Efex Pro to finish it off.

The Recipe for Getting This Type of Shot

Characteristics of this type of shot: On-location flash, with just a hint of light.

(1) The key to this shot is how you position the flash. Mount your flash on a light stand and use a small softbox (or shoot-through umbrella, but I really think you get much better, more concentrated results from a small softbox like a Lastolite EzyBox).

(2) You want to position the light up higher than your subject, aiming down, so it's aimed at your subject's face, but the angle is such that the light then falls on the ground and doesn't spill too much on the background, so the rest of the scene falls to black. To keep from having the ground too bright, you're going to pull a trick that is half a camera trick, and half a Photoshop trick (like I mentioned in Chapter 2).

(3) Set your camera to continuous shooting (or burst) mode (you'll need to press-and-hold the shutter button until your camera takes two rapid-fire shots). The flash will fire with the first shot, but won't have time to recycle for the second shot, which is great, because you need one that shows the ground below your subject without flash. Open both photos in Photoshop. Get the Move tool, press-and-hold the Shift key, and drag the shot without flash on top of the one with flash. Option-click (PC: Alt-click) on the Add Layer Mask icon at the bottom of the Layers panel to hide the one without flash behind a black mask. Take the Brush tool, set your Foreground color to white, choose a medium-sized, soft-edged brush, and paint over the ground to bring the ground without the flash back in, for a very natural-light look.

Index

L

Perfect your photography from shoot to finish.

Adobe® Photoshop® Lightroom® 4 software lets you perfect your images, organize all your photographs, and share your vision — all with one fast, intuitive application.*

- **Get everything you need beyond the camera:** Organize, perfect, and share — Lightroom combines all your digital photography tools in one fast, efficient application. Use powerful yet simple automatic adjustments or take detailed control of every feature, from editing to sharing.

- **Get the best from every image:** Get the highest possible quality from every pixel in your images, whether you shot them with a pro DSLR camera or a camera phone. Lightroom includes a comprehensive set of state-of-the-art tools for tone, contrast, color, noise reduction, and much more.

- **Share effortlessly:** Craft elegant photo books and easily share your photographs on social networks or in web galleries, slide shows, prints, and more. Lightroom includes efficient tools to showcase your work for friends, family, and clients.*

Get your FREE 30-day trial at www.adobe.com/go/lr_books